IMAGES
*of* America

# ELLINGTON

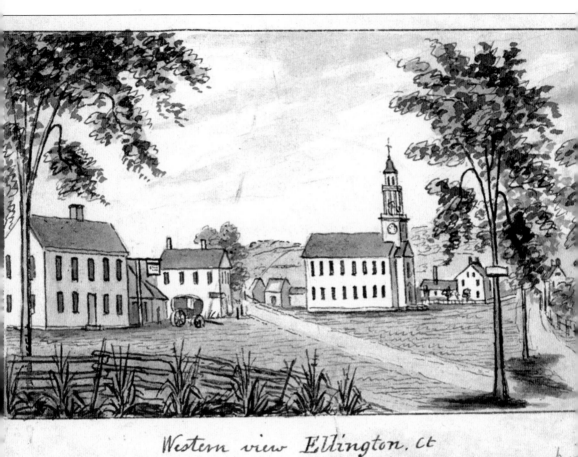

*Western view Ellington, Ct*

This drawing by John Warner Barber of New Haven is a view from the west looking toward the eastern hills of Ellington in 1836. The second church building of the Ellington Congregational Church, completed in 1806, stands in Church Park, opposite the present church. The second church had two stories and was fitted with box pews. The top third of the steeple was taken down in 1839 because the wood had rotted. The bell deck, open here, was later enclosed. After the third church was built across the street in 1868, this building was sold to Cyrus White and moved to Rockville where it was used as an opera house. The lower story was occupied by *The Rockville Journal*. Fire destroyed it in 1941. The house to the right of the church is the John Brockway house, where his daughter Emeline opened a small boarding school for girls in 1867. The Holton Tavern, which currently stands to the east of the Church of St. Luke on Maple Street, is on the left. (Courtesy of Connecticut Historical Society, Hartford, Connecticut.)

IMAGES
*of* America

# ELLINGTON

*For my friend Mary,*
*I hope you enjoy this*
*pictorial history of*
*my new hometown.*
*Lynn*

*Lynn Kloter Fahy*

Lynn Kloter Fahy
for the Ellington Historical Society

*Oct. 24, 2005*

ARCADIA

Published by Arcadia Publishing
Charleston SC, Chicago IL, Portsmouth NH, San Francisco CA

Printed in Great Britain

Library of Congress Catalog Card Number: 2005923942

For all general information contact Arcadia Publishing at:
Telephone 843-853-2070
Fax 843-853-0044
E-mail sales@arcadiapublishing.com
For customer service and orders:
Toll-Free 1-888-313-2665

Visit us on the Internet at http://www.arcadiapublishing.com

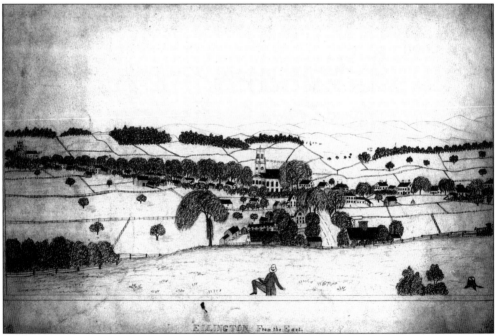

This pencil sketch of "Ellington from the East" was done by the Rev. George Wood, who was pastor of the Ellington Congregational Church from 1850 to 1854. He drew himself sitting with a sketch pad on the hill behind the present Meadowview Plaza on Route 83. Wood left his pastorate and Ellington because of ill health, but moved back at a later date. He stayed until 1891, when he moved to Washington, D. C. Harriet Beecher Stowe was a frequent visitor to his house at 36 Main Street, having become acquainted through a member of the Wood family who served as a governess near Stowe's home in Hartford.

# CONTENTS

# ACKNOWLEDGMENTS

A slide collection and extensive notes prepared by the late Nellie McKnight, town librarian and historian, gave me the confidence to take on this project. The executive board of the Ellington Historical Society encouraged the preparation of the book, and permitted the use of its photographic collection. Sue Phillips, director of the Hall Memorial Library, let me use photographs from the library's collection and also provided encouragement. Photographer Fred Bird provided photographs and negatives from his collection. Many of the negatives had been copied from private collections by those willing to share those images with the community, and I thank them, too. Fred was also a reliable source of advice on the technical aspects of this project.

Others who allowed use of their photographs were the Bahler family and Lee's Auto Ranch, Jim Brady, Peter Charter, Pat Clapp, Mildred Dimock, Charlotte Lanz, Tena and Dave Lehmann, Mark Maciolek, Lou Martocchio, Pam Strohm-Gorden, Nancy Schaefer, Ginger Taddeo, and Rob and Debbie Wallace. Mildred Dimock was also an invaluable source of information on local history.

The staff of the Trinity College Library and the Watkinson Library at Trinity were helpful in locating images in their collections. Also giving permission to use their photographs were the Connecticut Historical Society; the Archives and Special Collections at the Thomas J. Dodd Research Center, University of Connecticut Libraries; the Adams Museum, Deadwood, South Dakota; and the Ellington Congregational Church. A special thanks to Seiichi Narita, executive director of the Mitsubishi Economic Research Institute in Tokyo, for his help in providing information about Yanosuke Iwasaki, who attended the Edward Hall Family School for Boys from 1872 to 1873.

I would also like to thank my husband, Tim Fahy, president of the Ellington Historical Society, for his help and support in this project, which we hope will preserve the image of this charming town as longtime residents remember it, and introduce new members of the community to its rich and fascinating history.

# INTRODUCTION

Only 16 miles northeast of Hartford, the capital of Connecticut, Ellington has retained the charm of the New England farming community that it was when it was incorporated in 1786. To understand what makes Ellington so appealing to today's residents, you need only attend a summer Sunday concert at Arbor Park. Attending a concert there is like stepping into a Norman Rockwell painting. Situated in the center of town, Arbor Park is the perfect spot for the community to gather and listen to music. It drifts on gentle summer breezes as a band plays in the gazebo. Families spread their blankets in the shade of a tree and enjoy a picnic supper. Children practice cartwheels on the grass and dance to the music with childish glee. People on bicycles, scooters, and roller blades join strollers on the park pathways. What a wonderful, peaceful, way to end the weekend and make you glad you are a part of this community.

Ellington was first inhabited by Native American tribes. An ancient village that lay on the north shore of the lake was called Wabbaquasset by the Nipmucs, Square Pond by early settlers, and later, Crystal Lake. Ellington, also known as the "Great Marsh," was a part of Windsor and then East Windsor until its incorporation in 1786. A five mile corridor called the Equivolent extends eastward between Stafford and Tolland and includes the Crystal Lake section of town. When the Rev. John McKinstry became the first minister of the Ellington Congregational Church in 1733, there were only 11 families, and the town was still part of ancient Windsor. The first church, built c. 1738, stood on a site near the east end of the present library. It was a plain, unpainted, clapboarded building, 45 feet long and 35 feet wide. It served until the second meeting house, opposite the site of the present church, was dedicated in 1806.

From colonial times, water power from Broad Brook and the Hockanum River provided power for mills. A sawmill and grist mill operated by Roswell Sadd and later his son Sumner, lent its name to Sadds Mill Road, also known as Route 140. Tradesmen, storekeepers, tavern and inn keepers, carpenters, and peddlers all contributed their skills and hard work to the developing farm community. The Halladay Standard windmill, the first commercially successful windmill in North America, was invented and patented in 1854 in Ellington by Daniel Halladay. Used for pumping well water using wind energy, it made the settlement of the American West possible.

In the 19th century, the first Swiss immigrants to Ellington arrived to take jobs at area textile mills. Jacob Lanz arrived in 1886 with his five sons and two daughters from canton Bern, Switzerland, to become the first farmers from the Apostolic Christian Church in America to settle in the area. Among those who came during 1895 to 1905 were the families of Adolph and

Gottfried Bahler, and Fred Hoffman. The first church building on Fox Hill in Rockville was soon too small for the growing congregation, and a new church on Orchard Street in Rockville was built on land donated by Alfred Schneider. In 1954, the church moved to a new building at its present location, 34 Middle Butcher Road in Ellington.

The Jewish Agricultural Society, supported by the Baron de Hirsch Fund, was formed to promote farming among Jews in the United States. The society purchased small farms in Ellington, held the mortgages, and turned them over to Russian immigrants who wanted to become farmers. The farmers met in the homes of Aaron Dobkin, Samuel Rosenberg, and Louis Franklin. The first synagogue was built on the southeast corner of Abbott and Middle Roads in 1913 on land donated by Julius and Molly Sugarman. Knesseth Israel Synagogue was moved to its present site on Pinney Street in 1954, and was named to the National Register in 1995 as one of the historic synagogues of Connecticut.

The Ellington School, a private school established by John Hall, and his son Edward's Family School for Boys attracted students from around the world. Edward's brother Francis, who was America's leading business pioneer in Japan, gave the Hall Memorial Library as a gift to the residents of Ellington in 1903 in memory of his father and brother. An outstanding example of the Neo-Classical Revival architectural style, it is the jewel in the crown of Ellington Center. Classes, which in the early 18th century met in private homes, moved to school buildings that were built around town near groups of farm families. Each district was responsible for its own school. By 1824, there were nine districts in town. Most of the school properties were transferred to the town of Ellington in 1898. In 1949, five school buildings were sold at auction, and the new Ellington Consolidated Elementary School, now known as Center School, was built on Main Street at a cost of $260,000.

The Ellington Center Historic District was named to the National Register of Historic Places in 1990. The district includes Maple Street from Berr Avenue to just west of the high school and Main Street from Tomoka Avenue to East Green. The district is notable architecturally for the variety of architectural styles from 18th-century Colonial to late-19th- and early-20th-century Colonial Revival. Many fine examples of these styles line Main and Maple Streets, surrounding the central open space of the town green. It retains its integrity and the character of a picturesque New England village.

The community is changing rapidly, and farmland is being replaced by housing developments and shopping centers. The town is experiencing rapid growth and is examining how current state land use and tax policies influence residential and economic development, traffic, open space, taxes, and schools. The population has grown from 1,056 in 1790, four years after its incorporation, to an estimated 13,952 in 2003. The 21st-century challenge now before the town is to preserve its rural charm for longtime residents as well as for the increasing number of newcomers who have chosen to make Ellington their home.

# One

# Early settlers of the Great Marsh

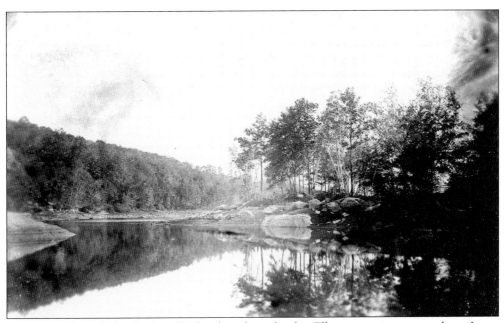

Shenipsit Lake, called "The Snip" by local residents, borders Ellington on its western shore. It was a favorite fishing spot and campsite for the Nipmuc, Podunk, and Mohegan tribes. It is the source of the Hockanum River, which provided power for mills in Ellington and Rockville. A popular recreational area in the 19th century, it is now a reservoir for the Connecticut Water Company.

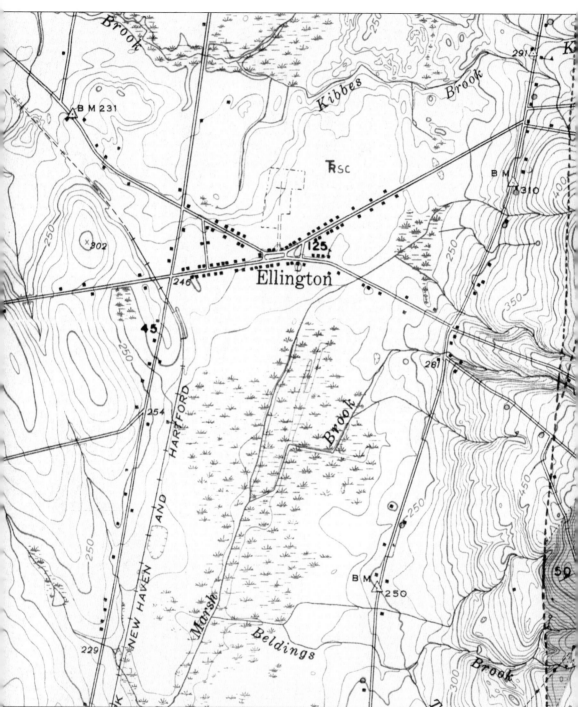

Glacial erosion scoured the bedrock crust of the Earth and formed the flat land and rolling hills of Ellington. When the ice melted, silt, sand, and boulders were left behind. The flat, fertile Central Valley of Connecticut was created by an ancient lake, named Glacial Lake Hitchcock, which deposited fine-grained sediments that make this area the finest agricultural land in New England. The hills of the Eastern Uplands rise abruptly out of the Central Valley. The Eastern

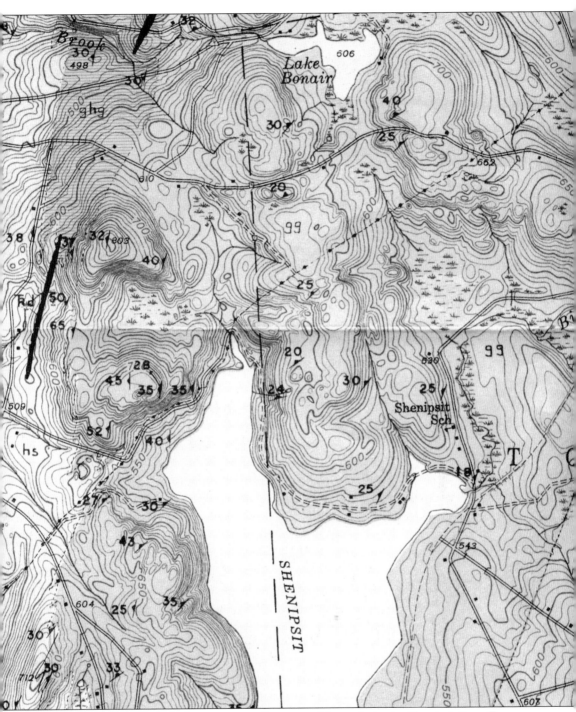

Wall can be seen from the lookout tower on Soapstone Mountain in the Shenipsit State Forest, on the Ellington-Somers town line. This 1946 U.S. Department of the Interior Geological Survey map shows the marsh between Pinney Street to the west and West Road (Route 83) to the east, where the darker gray area represents the abrupt rise to the Uplands and Shenipsit Lake.

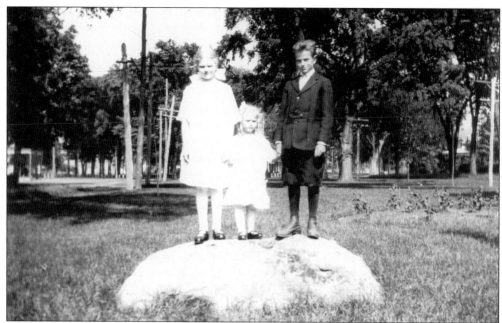

Mary (left), Elizabeth, and Edwin Davis stand on the "Indian Stone" in front of Hall Memorial Library in 1914. Town legend has it that the hole in the stone was used by the Native American Nipmucs as a mortar to grind corn. Robert Hyde used a team of horses to drag the heavy stone from Somers Road to its present position in front of the library.

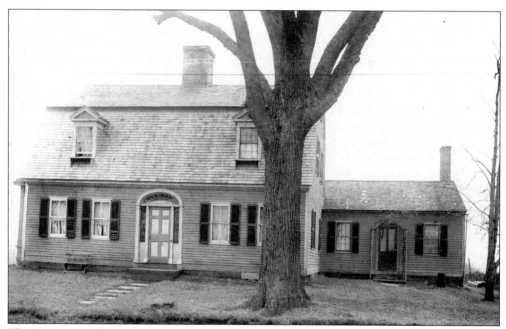

This Main Street house, still a private residence across from the Fire Station, was built by Charles Ellsworth around 1750. He was the grandson of Lt. John Ellsworth, who came from East Windsor in the spring of 1720 to clear land and build a small house on the east side of a place known by the English as "The Great Marsh" and by Native Americans as "Weaxkashuck."

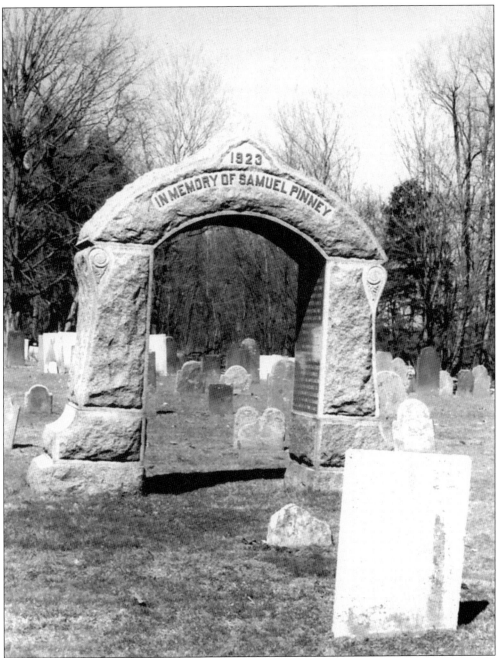

Ellington was a part of Windsor and then East Windsor until its incorporation in 1786. Samuel Pinney II first bought 30 acres of land in what is now Ellington in 1723. Samuel II was the grandson of the patriarch of the Pinney family in America, Humphrey. On May 30, 1923, the Samuel Pinney Memorial Arch was dedicated in the Ellington Center Cemetery. A reading, "The Mary and John," commemorated the 400-ton ship on which Humphrey Pinney sailed from Plymouth, England, to Boston, Massachusetts, in 1630. The hymn "Oh, God Beneath Thy Guiding Hand" was sung, and remarks were made by descendant William Nelson Pinney before the arch was unveiled.

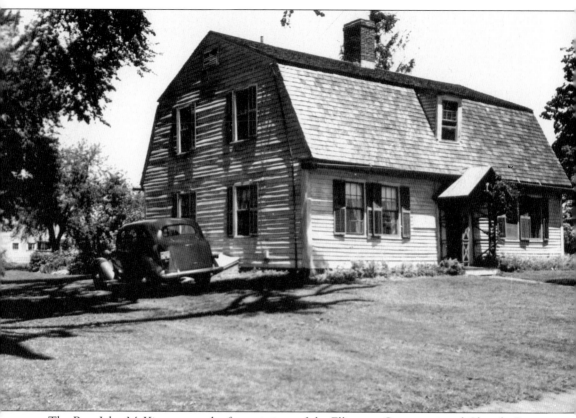

The Rev. John McKinstry was the first minister of the Ellington Congregational Church. Born in Ireland to Scotch parents in 1677, he became pastor of the church in 1733. There were only eleven families, and the town was still part of ancient Windsor. This 1730 gambrel-roofed house may have been his. It was moved to Maple Street in 1815 from its original location on the north side of Main Street near the corner of Tomoka Avenue.

The Rev. McKinstry died on January 20, 1754, at the age of 77. He had served as pastor until 1749 when he was dismissed by the congregation. Due to the disagreement with his parishioners, he did not want to be buried in the town cemetery. In this 1898 photograph, the McKinstry family burying ground is shown before the Hall Memorial Library was built. Since its 1992 expansion, the library now surrounds the cemetery.

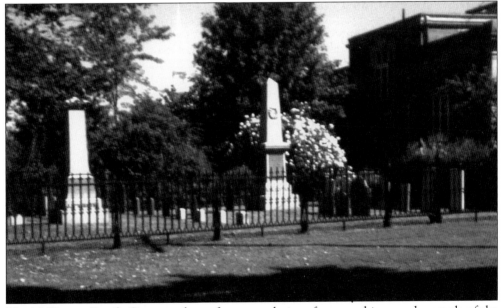

The McKinstry Family Cemetery has a fine, wrought-iron fence, and is a good example of the stone cutter's art in the 18th and 19th centuries. The first graves dug in the McKinstry cemetery were for the Reverend's infant grandchildren, who died in 1750 and 1754. The fence and a new monument were erected by descendant William McKinstry in 1859.

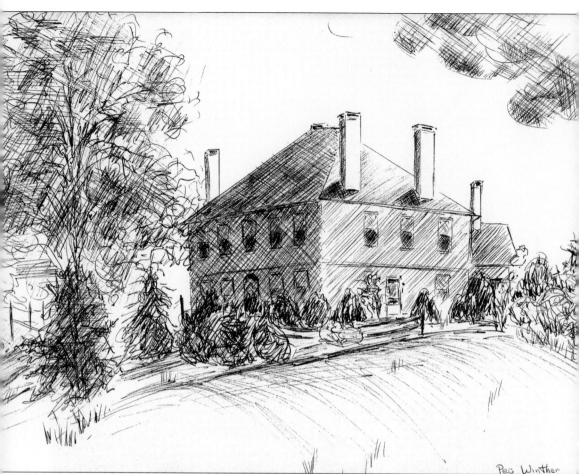

Peg Winther

Eleazer Pinney, Samuel's grandson, built the white brick house that has come to be known as the Pinney House. Lt. Eleazer Pinney was born in Ellington in 1752 and was 23 years old at the beginning of the Revolutionary War. He distinguished himself in the campaign against Burgoyne and the battles of Stillwater and Saratoga in 1777. After his return to civilian life, he was a representative in the legislature and a selectman in Ellington for 14 years. The Georgian hip-roofed style of the Pinney House is formal and symmetrical. The central hall was used for entertaining and as a community room. A Pinney descendant recalled feasts spread for family and friends in the great hall. This pen and ink drawing was done by Peg Winther, who was a longtime resident and member of the Ellington Historical Society.

# *Two*

# HALL MEMORIAL LIBRARY

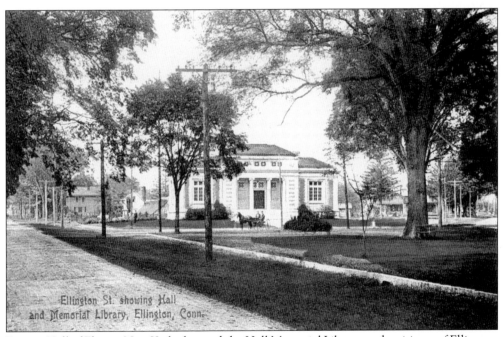

Ellington St. showing Hall and Memorial Library, Ellington, Conn.

Francis Hall of Elmira, New York, donated the Hall Memorial Library to the citizens of Ellington in honor of his father and brother. It was dedicated on November 11, 1903, nearly a year after his death. This postcard view of the library in the years after its dedication shows a horse and buggy on Park Street, which was eliminated when the addition to the library was built in 1992.

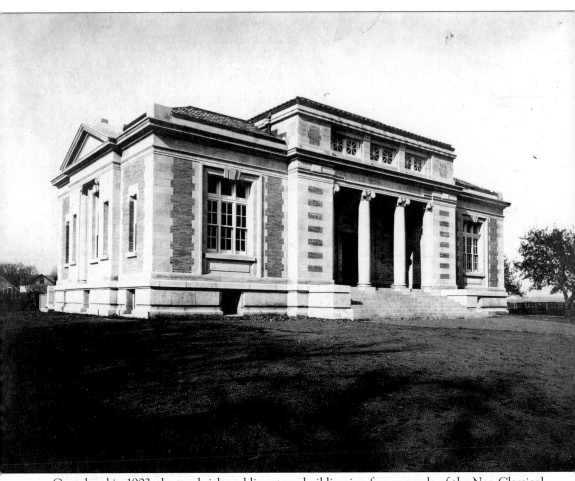

Completed in 1903, the tan brick and limestone building is a fine example of the Neo-Classical Revival style. The original roof was made of red clay tile and was flat with a skylight over the upstairs hall. It is said to have leaked, and the present roof is more steeply pitched. When the Ellington Center Historic District was named to the National Register of Historic Places in 1990, it was noted that the " . . . library is like nothing else in the district, obviously the product of a designer whose references were found elsewhere than in Ellington." The architect was Wilson Potter of New York and the contractors were Carpenter and Williams of Norwich. For the 1992 expansion, bricks were custom fabricated and imported from Kansas where the clay soils most closely approximated the colors of the original brick. Limestone trim was mined, fabricated, and shipped from Indiana for a perfect match to the original stone.

Francis Hall, pictured here with his sister-in-law, Mrs. Edward Hall, was born in Ellington on October 27, 1822. After completing his course of study at the Ellington School in 1838, he established a bookstore in Elmira, New York. Later, he became America's leading business pioneer in Japan. Called Japanese Frank Hall in Ellington, he returned to the United States and Elmira in 1866.

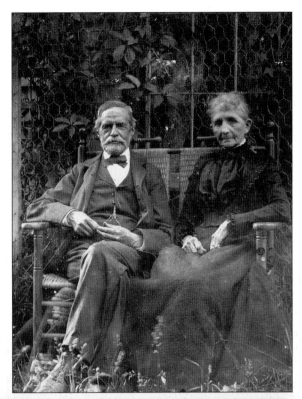

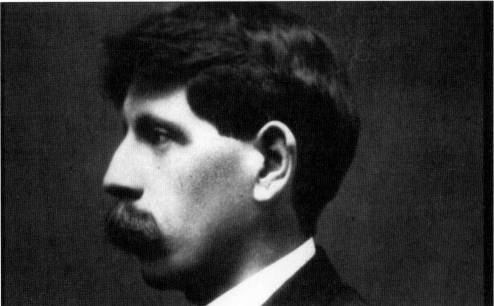

Ernest Bancroft started work as the first librarian of the Hall Memorial Library on Thursday, November 12, 1903, the day after its dedication. In his address, the Honorable Charles D. Hine, secretary of the state board of education, said: "This building will be an enduring memorial of the donor. It will see generation after generation come and go. It will become . . . a standing record of the life of this community."

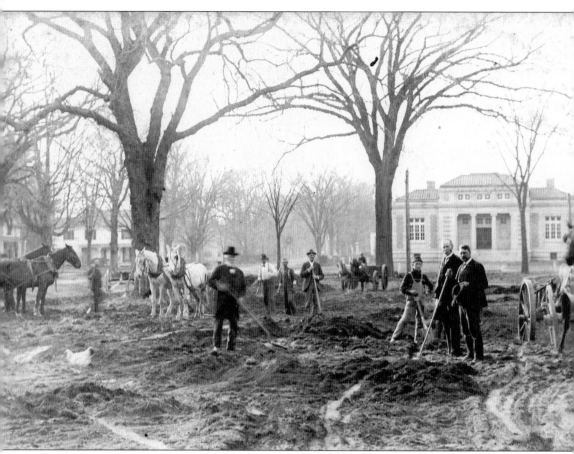

A crew under the supervision of John T. McKnight pause in their work as they landscape the village green to the east of the new Hall Memorial Library in 1903. Teams of horses and shovels were the tools of the day, and a chicken has joined in the activities. The main entrance of the handsome Neo-Classical Revival building of brick and limestone with its original red clay tiled roof faced east.

On a visit to the United States in October 1901, Baron Yanosuke Iwasaki, the second president of the original Mitsubishi Company, gave $2,000 to the building fund of the Hall Memorial Library to establish a Japanese collection in honor of his former teacher, Edward Hall. Instead, the money was used to pay for this set of three leaded glass windows portraying Edward, John, and Francis Hall.

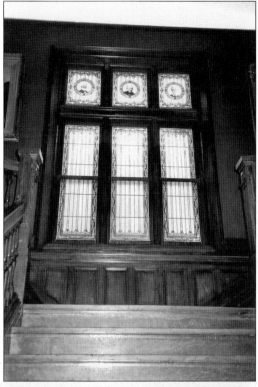

Ida Bancroft succeeded her brother Ernest as librarian from 1905 until 1916. She was a good friend of Nellie McKnight, who later became the town librarian. We can picture her, dreamy in her long white dress in this photograph, sweeping through the handsome wainscoted rooms and up the broad main stairway toward the wide landing where the stairway divided and ascended to the second floor in two flights.

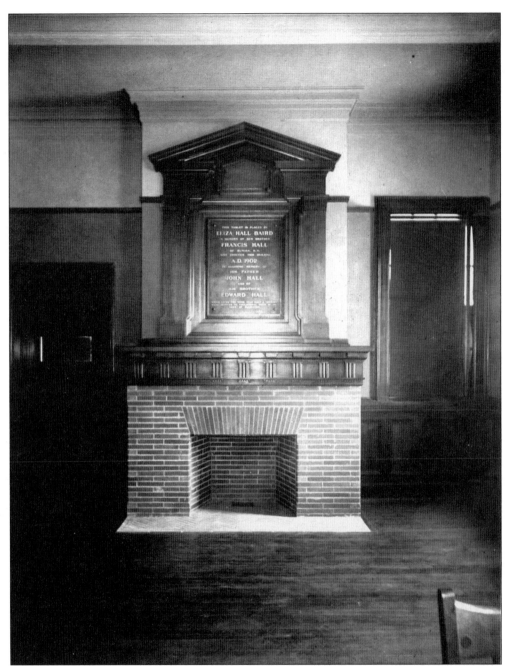

This large brick fireplace with its handsome oak mantel is in the original 1903 building of the Hall Memorial Library. The inscription reads: "This tablet is placed by Eliza Hall Baird in memory of her brother Francis Hall of Elmira, New York, who erected this building A.D. 1902 in honoring the memory of his father John Hall and of his brother Edward Hall, whose lives for more than half a century were devoted to educational excellence in the Town of Ellington." Francis purchased the land from Chauncey T. Chapman, selected the architect and contractor, but died in 1902 soon after construction began. He left instructions in his will for his brothers to spend $30,000 to build and equip the library.

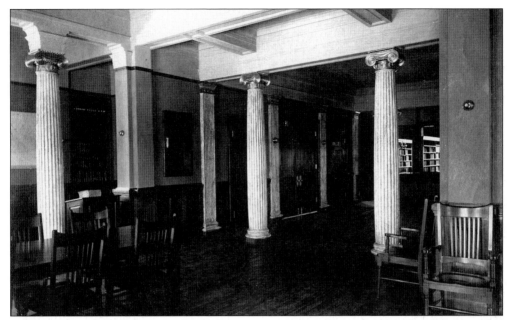

Visitors to the present Hall Memorial Library may recognize the spacious reading room pictured in this 1903 photograph of the original library even though there is a bank of computer terminals in what is now the reference area. The oak wainscoting, Ionic columns, and deeply paneled ceilings remain. The double oak doors were once the main entrance to the library on the east side of the building.

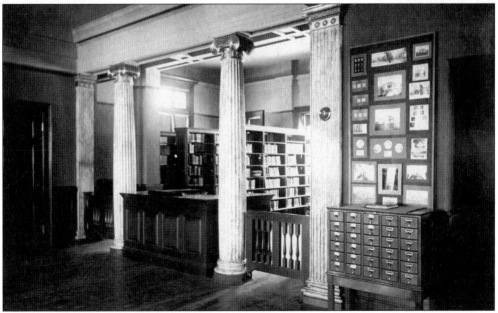

Fluted cast iron Ionic columns surround the circulation desk in the 1903 library. Books can be seen in the closed stacks behind the desk. A library patron would request the book which he had identified by searching the card catalog. The librarian would then retrieve the book from the stacks. The picture display above the card catalog in this photograph features exterior views of the new library.

The Rev. David Jones, 19th and current pastor of the Ellington Congregational Church, spoke at the dedication of the Hall Memorial Library, as did the Rev. Nathaniel Eggleston, the ninth pastor, who had left Ellington 53 years before. Francis Hall's brothers, Frederic, Robert, and Charles, supervised the completion of the library after his death in 1902 and presented it to the town.

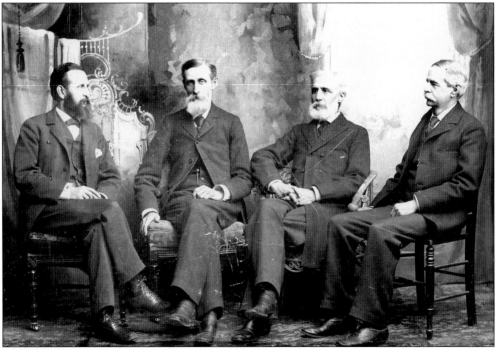

The four Hall brothers pictured here are, from left to right, Frederic, Robert, Charles, and Francis. Francis Hall taught in district schools before opening a bookstore in Elmira, New York. His adventurous spirit led him to Japan in 1859. In 1902, Francis donated money to his hometown of Ellington for a new library.

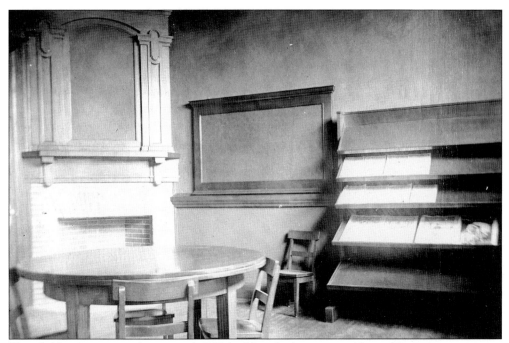

The children's room in the original 1903 building looks quiet and bare. However, generations of Ellington's children borrowed books, listened to stories told by Nellie McKnight, and filled it with their happy chatter. The 1992 addition to the library relocated the children's library to a spacious and bright area on the second floor of the new wing.

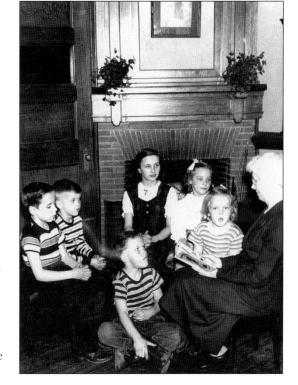

Nellie McKnight loved to read to children. Many adults recall sitting on the stairs at the library while Nellie read to them. She is pictured here reading to a group of schoolchildren in front of the fireplace at the library around 1951. The girl in the dark jumper and white blouse is Barbara Dziadul and the girl in the white blouse is Denise Krowchenko. The other children are unidentified.

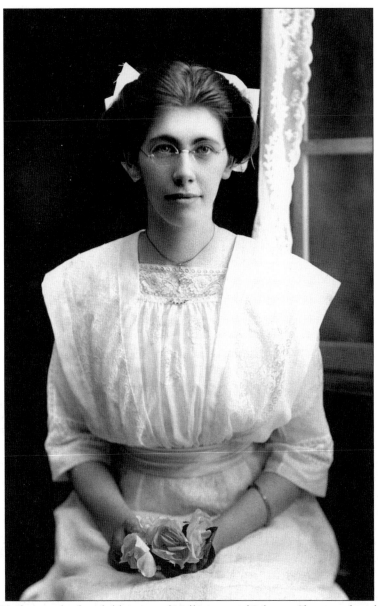

Nellie McKnight was the fourth librarian of Hall Memorial Library. She served in that position for 38 years, from September 1, 1929, to August 31, 1967. Nellie was born on July 22, 1894, on her father's farm at the intersection of Sadd's Mill Road and Muddy Brook Road. She is pictured here in 1913 at her high school graduation. A graduate of Rockville High School and Mt. Holyoke College, she taught German, Latin, and English in high schools in Massachusetts and Connecticut before returning to Ellington in 1929. In her freshman year at Mt. Holyoke College, she wrote in her diary that all the students at the dinner table had nicknames. She was "The Silent Partner." When Nellie found her life's work as a librarian, she bloomed as did her legendary night-blooming cereus. Friends were honored when they received her call that it was time for the flower to open, and they were invited. After her retirement, she wrote an historical pamphlet, "Ellington, Glimpses of Earlier Days." She was named to the Ellington "Wall of Honor" in 2001.

*Three*

# THE VILLAGE GREEN

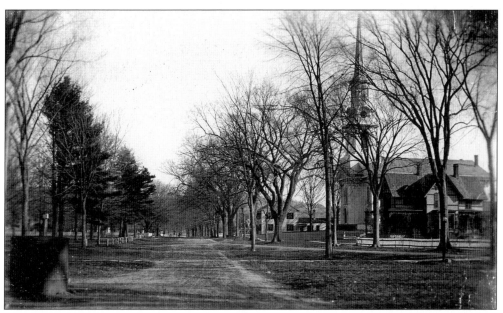

Ellington Center Historic District was entered in the National Register of Historic Places in 1990. The village green and the quality of the architecture define the historic New England village. In this view of Main Street, the H. H. McKnight home, now the Nellie McKnight Museum, is east of the third building of the Ellington Congregational Church. The Rufus Leonard House, built in 1884, is in the foreground.

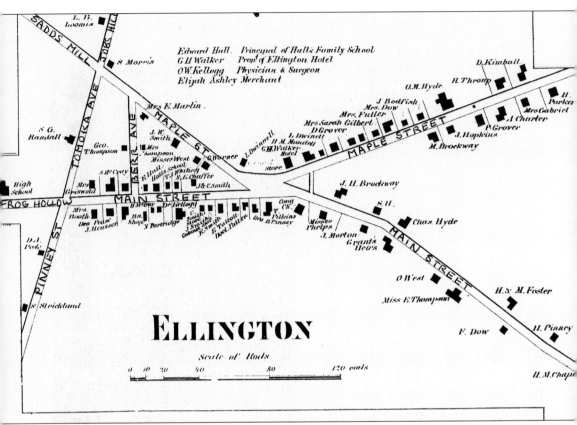

The 1869 map of Ellington Center and the village green shows streets that are familiar to today's residents. The second building of the Ellington Congregational Church, which had been in the triangle-shaped Church Park at the eastern intersection of Main and Maple Streets, had been moved to Rockville. The location of the third church building, which had been completed the year before, is marked on the south side of Main Street.

Dr. Robert Patton and his wife lived in a 1793 Georgian Colonial with Federal and Greek Revival features on the south side of Main Street. Dr. Patton started his practice in 1842 and was the first dentist known to have practiced in Ellington. He died of the flu in December 1891. His grave in Ellington Center Cemetery is marked by this large tooth-shaped boulder which was brought down from the eastern hills.

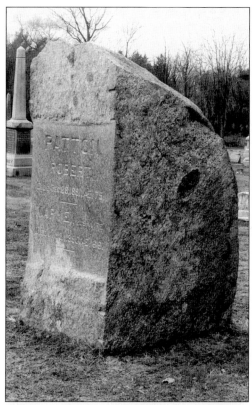

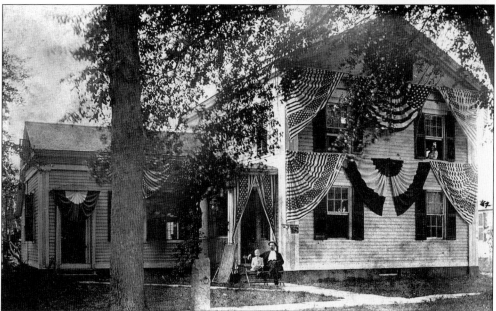

Dr. Edwin T. Davis and his four-year-old son, Harold, sit outside their house on the south side of Main Street, decorated for the Fourth of July in 1897. Mrs. Davis leans out of an upstairs window. The doctor's buggy, drawn by one of his faithful Morgan horses, became a familiar sight on the country roads. This Greek Revival house on the green is still a private residence.

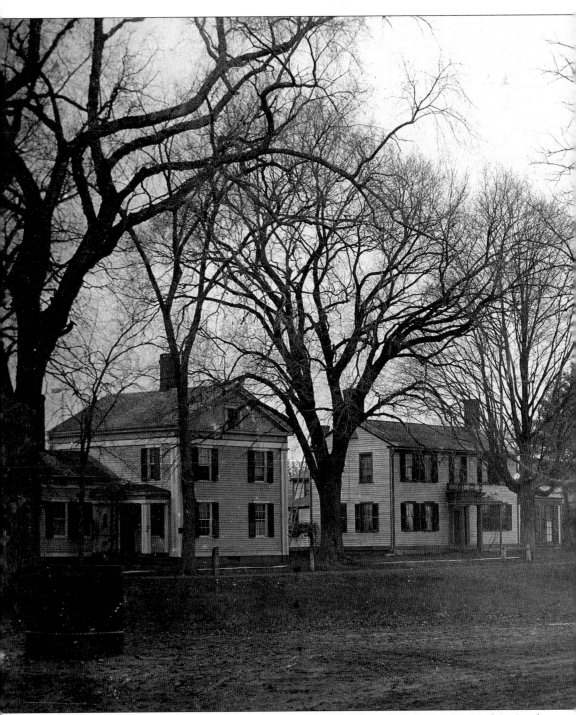

This *c.* 1891 view of the south side of Main Street from Maple Street shows a 44 star flag. On the 1869 map of Ellington Center, the houses are, from left to right, Benjamin Pinney, Dr. Patton, E. Talcott, E. Smith, J. Smith Cabinet Shop, C. Smith Store, and Dr. Kellogg. John Smith made furniture and coffins for townsfolk in his shop. In this photograph, Erwin Miller's grain building is in the location of the former cabinet shop. It was moved to Maple Street around 1930 and

demolished in 2002 as part of the Center School building project. The Liberty Pole on the town green was a symbol of freedom in Colonial America. On October 11, 1975, members of the Ellington Parish Train Band raised a symbolic Liberty Pole on the green during Freedom Festival Day activities. It is still standing.

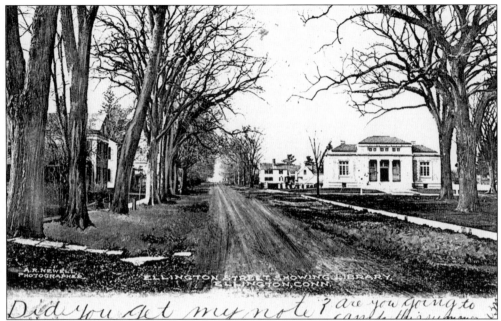

Many of the stately trees that line the south side of Main Street in this postcard view were destroyed in the hurricane of 1938. The Harold and Emily McKnight Davis house to the west of the Hall Memorial Library was demolished when the library parking lot was enlarged. Further west is the 1813 Obadiah Ward house, a two-story frame Federal and Greek Revival house, with the gable end toward the street.

For many years the home of Guy and Marionette Collins, this house on Maple Street facing the village green is best known today as the Scandinavian Gift Shop. It was built in 1827, one of the many Greek Revival style houses built in the second quarter of the 19th century, the historic district's period of fastest growth. A wraparound porch with Queen Anne features was added later.

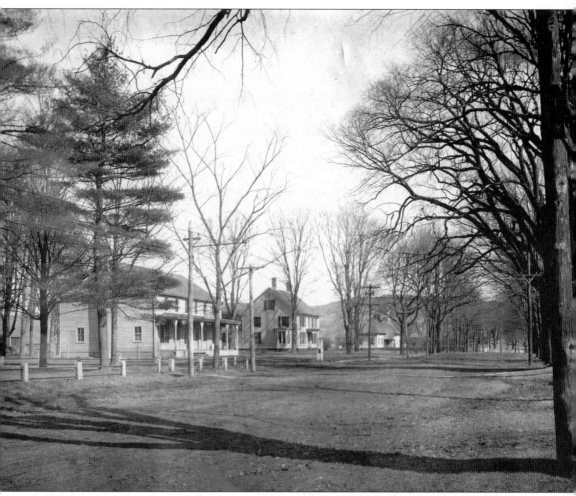

Standing at the east end of the green on an unpaved Main Street looking toward the eastern hills before the town hall was built in 1915, from left to right, are the Parkview Cash Grocery, the Francis Charter house, and the old Center School. The Charter house is marked on the 1869 map as "JS Brockway." It was the home of John Brockway, state representative and senator, state's attorney, and son of the Congregational minister Diodate Brockway. Charter bought the house around 1902. When he was named postmaster in 1906, the post office was moved to the southeast room of his house. He also owned and operated the grocery. None of these three buildings are still standing.

In this *c.* 1910 view of the John Robinson house and children at 107 Maple Street, the Ellington Center Cemetery can be seen to the left of the house. Robinson's blacksmith shop was in the rear of the house, built in 1890. The house is still a private residence. The low tower with the pyramidal roof is still evident, but alterations have removed other features of its Queen Anne style.

The children of John and Kate Robinson gather for a photograph on the village green across from their Maple Street home in 1915. The children are, from left to right, Gladys, William, Charles, George, and Clarence, who is next to baby Vera in the carriage.

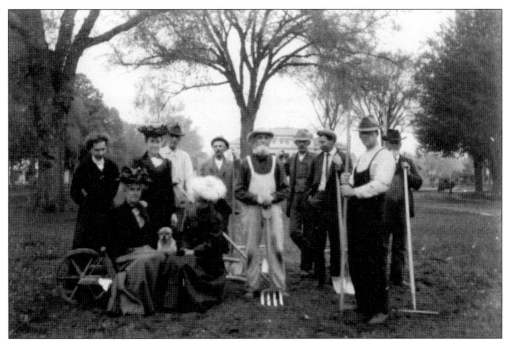

This picturesque group is gathered in West Park on the village green to plant a flower bed. From left to right are Maud Kimball, Mrs. Edgar Pease, Mr. and Mrs. John Miller, unidentified dog, Ida M. Bancroft, Horton T. Noble, a Mr. Buckingham, Fred Aborn, Alonzo Peck, and Frank Bancroft.

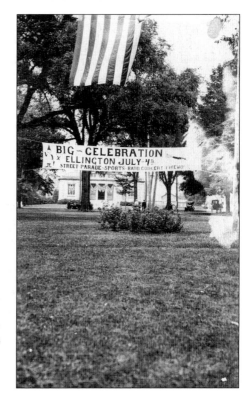

This banner in West Park in front of a bunting-draped Hall Memorial Library promises a Fourth of July celebration featuring a street parade, sports, fireworks, and a band concert. An article in *The Rockville Journal* on July 1, 1897, mentions participants climbing a greased pole and catching a greased pig. A ceremony in Center Park included a speech by Dr. Edwin T. Davis.

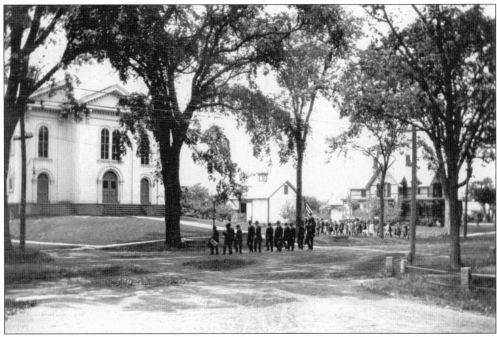

This scene shows the third building of the Ellington Congregational Church before it burned down in 1914. In what may have been a Memorial Day celebration, a drummer leads the group of men while a group of schoolchildren carry the flag.

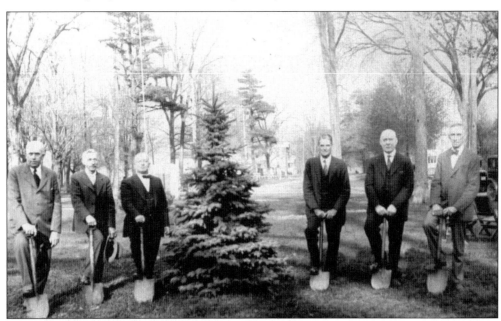

Members of the Ellington Grange plant an evergreen tree in West Park on the village green in the early 1930s. From left to right are R. Allen Sikes; Henry Felber, first Selectman; Earl Hatheway, master of the grange; Milo E. Hayes; Marshall Charter, town clerk; and Morton Thompson. This tree had to be replaced twice, due to disease and an auto accident. The present tree is decorated with lights every December.

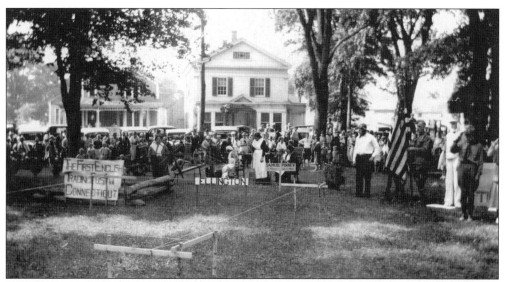

The Ellington Tercentenary Celebration went on for three days, beginning June 21, 1935. It was in commemoration of the 300th anniversary of the settlement of Connecticut. Townspeople assembled on the village green where pageants were staged. In this view looking north toward houses on Maple Street, one episode depicts the first English trading post in Connecticut in Windsor, while another depicts early Ellington settler Samuel Pinney building a log cabin.

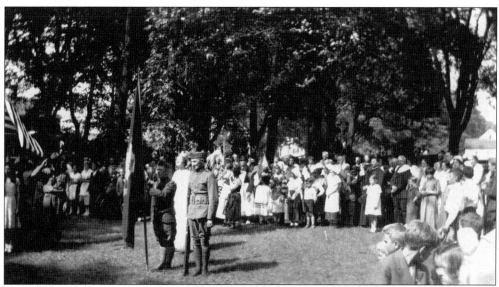

At 10:00 a.m. on a sunny Saturday of June 22, 1935, the flag raising by the Boys Scouts of Ellington kicked off the second day of the Ellington Tercentenary Celebration. A parade, speeches, and the awarding of prizes in the school poster pageant preceded the afternoon pageant in Church Park on the village green.

Looking west, we see a large tree shading an unpaved Main Street in front of the fourth building of the Ellington Congregational Church. A colonnade of utility poles borders Church Park. The town post where notices were hung can be seen just to the right of the foremost pole. The Honor Roll in the park is just behind the post.

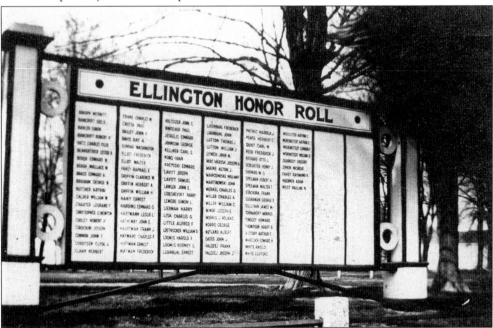

The Ellington Honor Roll, listing those who served their country in World War II, was erected in Church Park at the east end of the village green. Later, a granite monument memorializing World War II, the Korean War, and the Vietnam conflict was erected near the flagpole on the west end of the green.

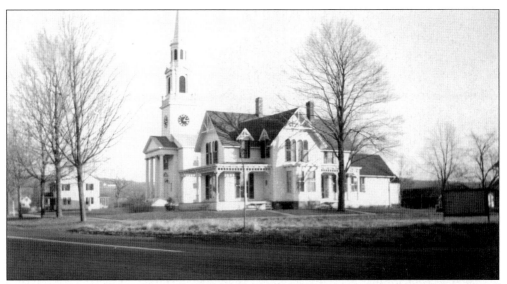

In this 1939 view of Main Street, the 1884 Rufus Leonard House graces the village green west of the fourth building of the Ellington Congregational Church, built in 1915. This handsome one and a half story house is an architectural blend of Italianate, Queen Anne, and Stick-style. An ell, which appeared in earlier photographs of the McKnight house in the background, has been moved to the house next door.

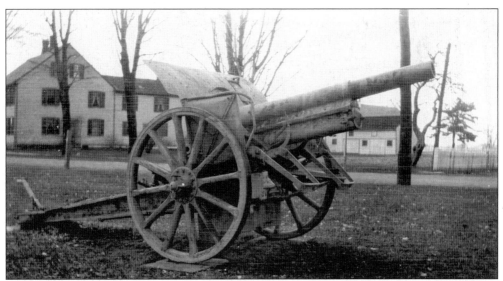

This cannon stood on the east end of the village green in front of Charter house, formerly the John Brockway house. Carl Miller of Rockville drove to New Jersey to pick up the government surplus cannon and delivered it to Ellington after Rockville declined it. It was later turned into scrap metal in World War II. The Charter house was demolished in 1970 when the shopping center was built.

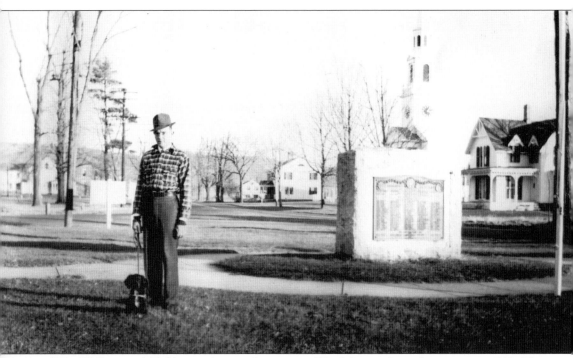

Don Wallace and Teddy stand near the granite War Memorial on the green in 1939. The bronze panel, engraved "Ellington Remembers," honors its sons who served up to 1926. When the monument was erected, the 1861–1865 Civil War was called "War of the Rebellion." The monument cost $1,667.97 plus donated time and materials. It was turned over to the town on May 31, 1926, by the Memorial Committee of Capt. Robert E. Hyde, George Hatheway, and John T. McKnight. Ellington still honors those who served with a parade and decoration of the monument each Memorial Day.

# *Four*

# VILLAGE HOUSES

Enjoying a game of croquet in front of the Charles Price home, around 1914 are, from left to right, Iva Price Sloan, her daughter Hazel, her sister-in-law Gladys, and her mother Louise Price. Charles Price was town assessor for over 30 years until his retirement in the 1930s. This Gothic Revival house on Maple Street was demolished in the 1990s when the addition to library was built.

Librarian and historian Nellie McKnight's parents bought this eight-room Federalist-style house at 70 Main Street in 1922. The McKnights made extensive renovations to the house, which had been built by Charles Sexton in 1812. At her death in 1981, Nellie bequeathed her house and furnishings to the Ellington Historical Society to be used as a museum. The Nellie McKnight Museum has recently undergone repairs to its foundation and heating system. Her loom has been restored and is in working condition. Some of the many coverlets, rugs, pillow coverings, and runners that Nellie made are on display in the museum. This photograph, showing trolley tracks, was taken after trolley service from Rockville began in 1906 and before the pictured third building of the Ellington Congregational Church burned in 1914.

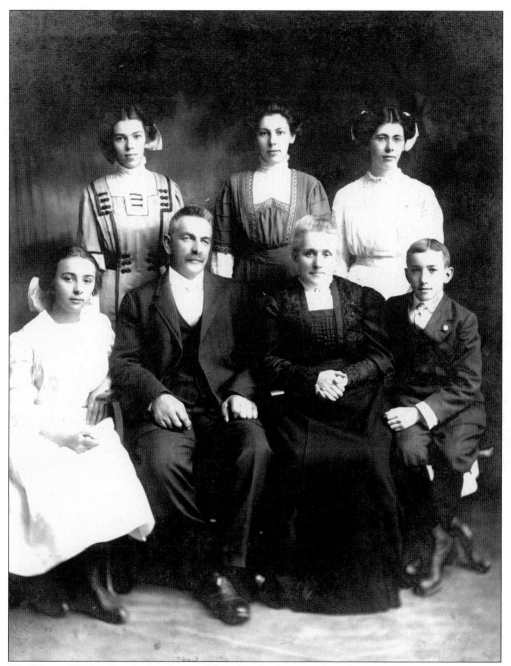

The Howard H. McKnight family posed for a family photograph at the Newell Studio in Rockville in 1911. Seen here are, from left to right, (front row) Frances, age 13; Howard, age 45; Clara Sikes McKnight, age 43; and Horace, age 9; (back row) Dorothy, age 15; Emily, age 17; and Nellie, age 16. Howard was manager of the Ellington-Vernon Farmers' Exchange, which purchased carloads of fertilizer and grain for the member farmers. The Exchange was the forerunner of Ellington Agway, today owned and operated by the Kupferschmid family. He represented Ellington in the Connecticut General Assembly for one term, was a past master of the Grange, a trustee and deacon of the Ellington Congregational Church, and a director of the Cemetery Association.

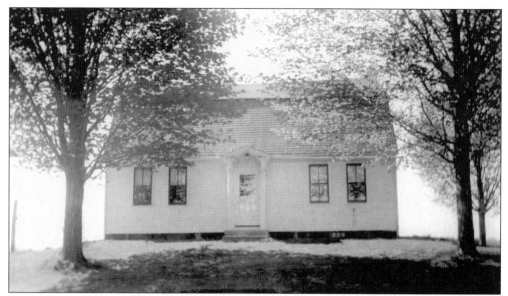

Located on a rise on the south side of Frog Hollow Road, east of the intersection with Pinney Street, is the Jonathan Buckland House. During the Revolutionary War, Buckland enlisted in Capt. Charles Ellsworth's Company on July 9, 1775. Ellington was still part of East Windsor. This house, which is still a private residence, is thought to have been built around 1760.

The Darius and Parmelia Crane family poses in 1886 outside of the family homestead on Crane Road, which extends north from Frog Hollow Road to Broad Brook Road, Darius was a representative from Ellington in the Connecticut General Assembly in 1850. He was also a teacher and a farmer who successfully grew woad, a source of blue dye used for dyeing cloth. Granddaughter Betsey, age two, holds her father William's hand.

Phoebe Hinsdale Brown and her husband, Timothy, who was a painter and carpenter, lived in this house at 103 Main Street. In 1818, she wrote a poem which became the well-known hymn, "I Love to Steal Awhile Away." She had four little children and a sick sister living in the only finished room. The Thomas J. Whiting family is pictured in front of the house around 1855.

Phoebe Brown used to walk at dusk to escape the cares of the day and to admire the fragrant fruits and flowers in a neighbor's lovely garden. Rebuked for intruding, Phoebe wrote a poem as an apology. The American Tract Society publication *The History of an Indian Woman*, or *Religion Exemplified in the Life of Poor Sarah*, about a Native American who lived at Shenipsit Lake, is attributed to her. (Courtesy of Watkinson Library, Trinity College, Hartford, Connecticut.)

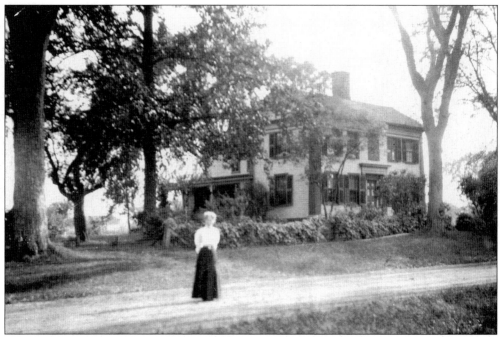

Ellen Delano is pictured here in front of her home, which she bought from the estate of her uncle Francis Hall after his death in 1903. Ellen was the daughter of Sophia Hall Delano. This Greek Revival house at 120 Main Street, built in 1832 by Nelson Chaffee, is still a private residence.

This photograph of the Elijah Pember house, built in 1768, was taken on January 31, 1936. Pember was one of only 58 freemen, or legal voters, out of a total of 1,000 inhabitants at the time of Ellington's incorporation in 1786. He served as representative from Ellington in the Connecticut General Assembly in the May session, 1797. The house on Somers Road was later owned by Charles B. Sikes Sr.

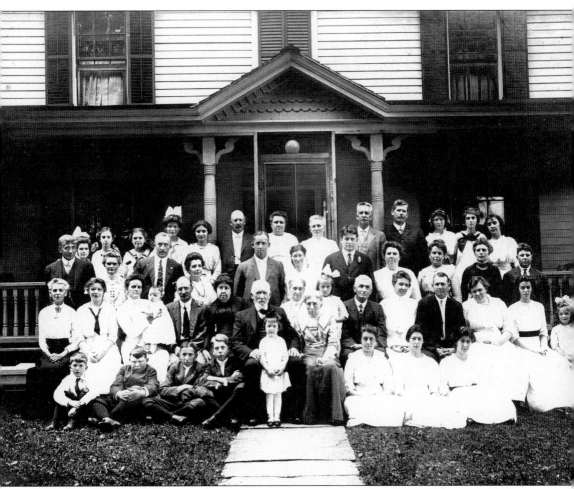

Patriarch "Grandpa" Charles B. Sikes Sr. presides over his 80th birthday party in 1914 at the Sikes homestead on the northwest corner of Somers Road and Meadowbrook Road. Here, from left to right, are (front row) Charles Williard Bugbee, Robert C. Sikes, Horace S. McKnight, Carroll Moore, Eleanor Percival, Mildred Sikes, Emily McKnight, Nellie McKnight; (second row) Julia Percival, Grace Sikes, Mildred Percival, Sterling Percival, Dwight Percival, "Aunt Louisa," Charles B. Sikes Sr., Mrs. Havens, Jane Beebe Sikes, Marjorie Sikes, Charles Bugbee, Eunice Kibbe Sikes, Buell H. Sikes, Iola Sikes, Dorothy McKnight, and Helene Percival; (third row) Lincoln Bugbee, Lennie Bugbee, R. Allen Sikes, Rachel Isabel Sikes, Horace A. Sikes, Marion Havens Sikes, Raymond Bugbee, Etta Bugbee, Mary Burt, Susan Moore, and Elbert E. Sikes; (fourth row) Isabel B. Havens, Lucille Moore, Emilie Bugbee, Edith Burt, Pearl Bugbee Noble, Charles B. Sikes Jr., Myrtie Hyde Sikes, Clara Sikes McKnight, Howard H. McKnight, Ed Burt, Frances Burt, Marjorie Moore, and Frances McKnight.

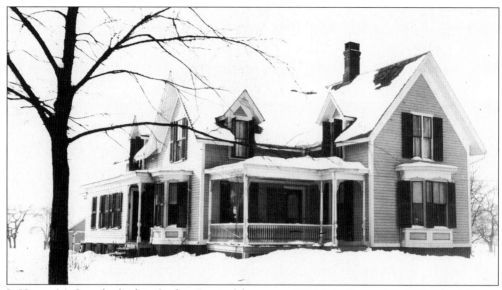

J. Henry McCray built this Gothic Revival house at 100 Main Street in 1876. The Morton Thompsons lived here from 1908 to 1958. Elizabeth Davis Goddard, the daughter of Dr. E. T. Davis, remembered the thick, rich sugar cookies called "Cookie Thoms" that Annie Thompson often handed out to the neighborhood children.

Jarvis and Katherine Clapp came from Vermont to live with the Morton Thompsons after their parents died. They often played with their Davis cousins who lived a few houses away on Main Street. Rolling hoops on the sidewalk was a favorite pastime. Katherine was eight years old and Jarvis was six in April 1910 when this photograph was taken on the back steps of the Thompson house.

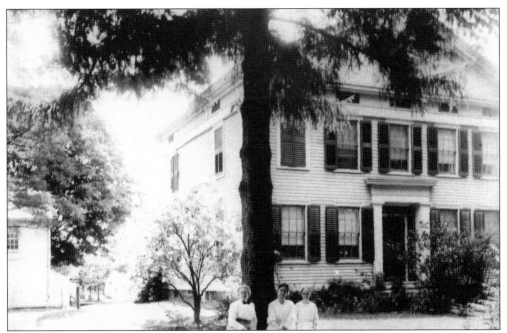

Three unidentified women rest by a tree in front of a house at 108 Main Street. The gable end of the Greek Revival house, built by Nelson Chaffee in 1839, faces the street. In the 1920s and 1930s, the house was occupied by Claude Pease and his sister, Marion, who moved from Illinois. Jarvis and Helen Hyde Clapp bought the house from the Peases in 1957.

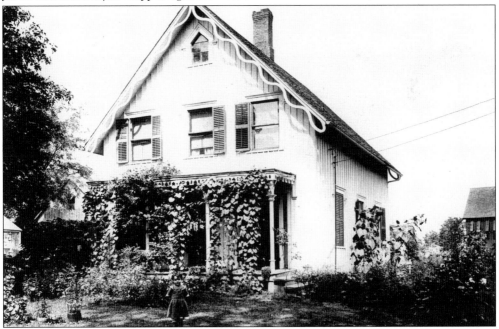

The Greek Revival building boom in Ellington was followed by the Picturesque period. This Gothic Revival cottage with board-and-batten siding appears to be a Greek Revival structure with Gothic alterations. Built in 1832, it is still a private residence at 101 Main Street. Violet Saidak, daughter of Andrew and Katherine, is pictured in the front yard around 1926.

W.W. Preston & Cº. N.Y.

Oliver Hyde, pictured here, was born in Ellington in 1810, the son of Dr. Allyn Hyde. He took over the homestead farm on the death of his father in 1855. Described as an ardent Republican, he held a variety of local and state offices. On November 9, 1887, he and his wife, Mary Thompson, celebrated their golden wedding anniversary in the house where they had spent their whole married life.

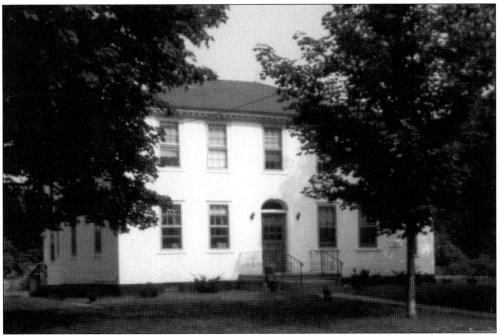

This two-story, brick, hipped-roof, Federal-style house on Maple Street was built in 1805. It is known as the Dr. Allyn Hyde house after its second owner. Hyde was born in Ellington in 1773 and received an honorary M.D. from Yale College in 1824. He and his wife, Jemima Mather, had three children. Dr. Hyde treated patients along the Broad Brook stream during a typhus epidemic in 1828.

Samuel Darby purchased two acres of land in November of 1841, just west of the present location of Ellington High School. This Greek Revival house at 57 Maple Street was built around 1842. Edward Barber bought the house in 1869, and it was later owned by his widow and daughter, Fannie Barber. Louis Schlude and his wife, Edna Warner Schlude were more recent owners. It is still a private residence.

The Daniel Kimball House is located on the west side of Somers Road, north of the intersection with Crystal Lake Road. Years ago an attempt to raise silkworms and grow the fresh mulberry leaves they needed for food was unsuccessful due to the New England climate. Young trees were dug up in the fall and set in sand in cellars for the winter. A few mulberry trees in sheltered spots have survived.

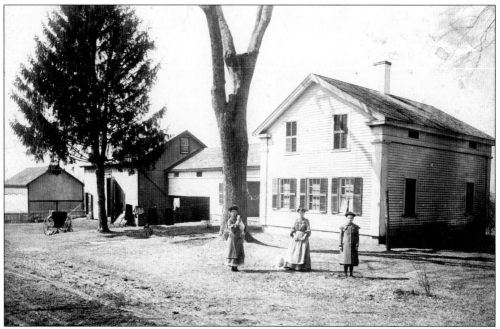

The corner of Somers Road and Meadowbrook Road is now the location of Limberger Trailer Sales. This house on the southwest corner, at 324 Somers Road, pictured in 1904, still stands. The women are, from left to right, Gertrude, age 17; Clara, age 20; and Flora Tuttle, age 15. Their father, Frank, bought the house in 1898.

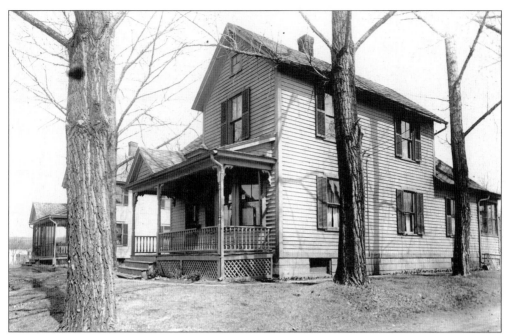

This 19th-century house is now the home of Hair Creations at 11 West Road. West Road in Ellington begins at the Vernon town line and extends north to the intersection with Main Street, Route 286, from where it is then called Somers Road. When it was laid out in 1738 it was the first public road in Ellington. Wooden bridges were built across the brooks.

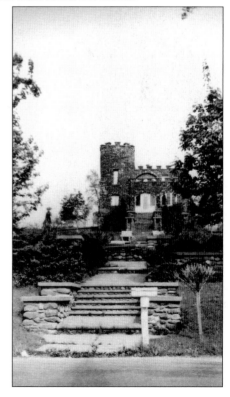

The Castle on Somers Road is an Ellington landmark. It was built in 1917 by mason Edgar Aborn for Harry C. Aborn, who owned the general store in Ellington Center. The Aborns' travels to Europe inspired them to build a castle like the ones they had seen. Avon Mountain can be seen from the top of the turret, which is reached by way of a spiral staircase.

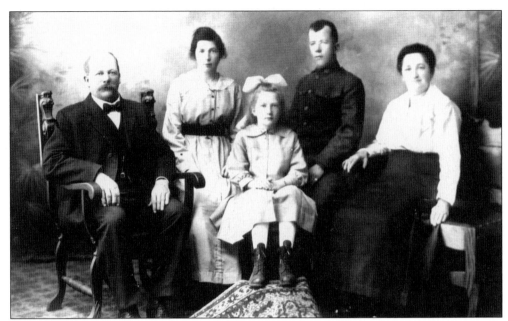

The Frank Batz family posed for this photograph around 1917. From left to right are Frank, Jennie, daughter Emma, Charles, and mother Emma. Charles died in 1992 and Emma in 1996. They were named to the Wall of Honor in 2004 for their contributions as public servants and for their gift to the town of forty-five acres of land to be used as a nature preserve.

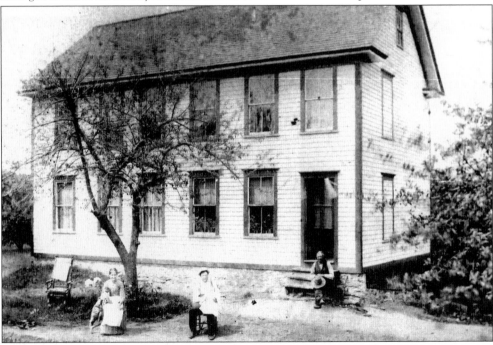

The Batz family homestead on Shenipsit Street is pictured here around 1897. Emma is seated on the left with three-year-old Charles, and Frank is holding infant Jennie. Neighbor John Wheelock is seated on the steps of the house. Batz and Wheelock were both listed as carpenters in the 1900 census. The house is no longer standing.

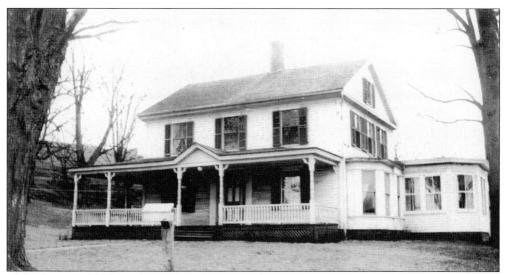

The James Dixon McKnight homestead is at the intersection of Muddy Brook Road and Sadds Mill Road. James built the house in 1850 when he married Mary Fidelia Thompson. John Dixon McKnight died at the age of 70 in February 2003. This fourth generation dairy farmer, the youngest son of Horace and Mildred Charter McKnight, was active in his sons' sand and gravel business and had continued farming in his retirement.

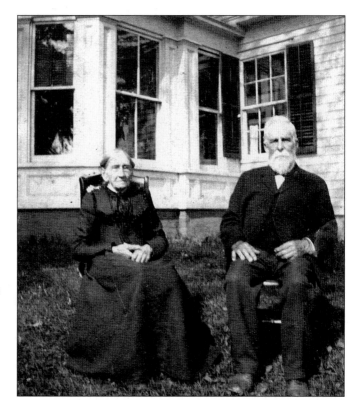

J. D. and Mary McKnight are pictured here in front of the family homestead in the Sadds Mill section of Ellington c. 1900. J. D. was the great-grandson of John McKnight, who emigrated to America from Scotland in 1731. Of the five children born to James and Mary, the youngest, Howard Horace McKnight took over the family dairy farm. One of Howard's and his wife Clara's children was Nellie McKnight, town librarian and historian.

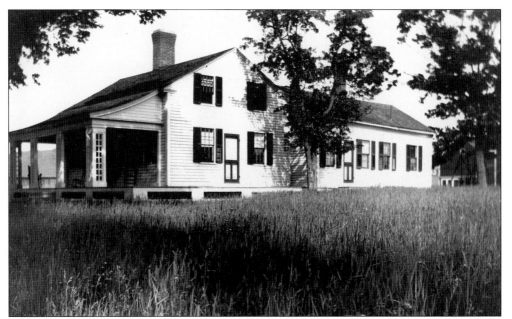

This *c.* 1820 Colonial Revival bungalow at 58 Maple Street was built by Aaron Charter. E. Brainard Kibbe added the porch with a long sloping roof supported by lattice-work posts. The north door on the west side has been removed since the photograph was taken. The empty rockers on the front porch suggest that the occupants may have stepped inside for another pitcher of lemonade on this fine summer day.

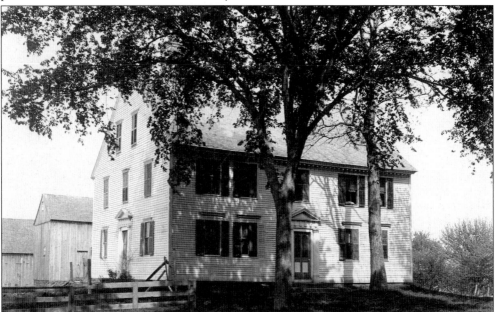

The Chester Chapman House served as the fourth home of Fayette Lodge No. 69 A.F. and A.M. from 1833 to 1857. It stood on West Road opposite the present Valley Farms and was destroyed by fire in 1977. The Masons met secretly during a time of persecution in the southeast corner front room on the second floor. All the Masonic paraphernalia were stored here until the lodge moved to Rockville.

*Five*

# VILLAGE LIFE

Earl Aborn Rich was almost 12 years old in October 1933 when this photograph was taken near his home at the corner of Somers and Cider Mill Roads. The house in the background was most recently used as a bank. Rich was named to the Ellington Wall of Honor in 2002 for his service to the town as a selectman and fire chief of the Crystal Lake Fire District.

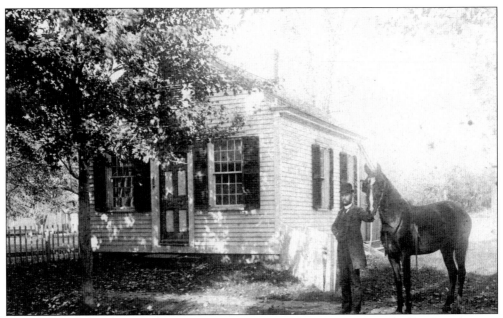

Dr. Edwin T. Davis opened his first practice on Brooklyn Street in Rockville. One day two farmers from Ellington came to his office to invite him to open an office in the village, because of the long illness of Dr. Everett J. McKnight. Davis is pictured here in 1891 with his Morgan horse in front of his office on Maple Street, which stood where the driveway to the cemetery is now located.

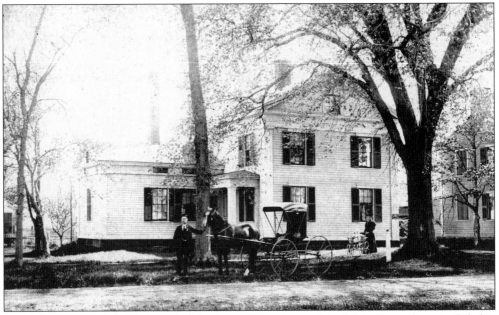

Dr. Davis poses with his horse and buggy in 1894 in front of his Main Street home, while his wife, Lottie, pushes Harold in a carriage. Office calls cost 50¢, a house call $1.00, and a delivery $5.00. Payment was often made in services or goods. Dr. Davis' account books show receipt of 10 pounds of sugar, a wagon load of wood, a cow, a bushel of onions, 555 pounds of ice, and a buckboard wagon.

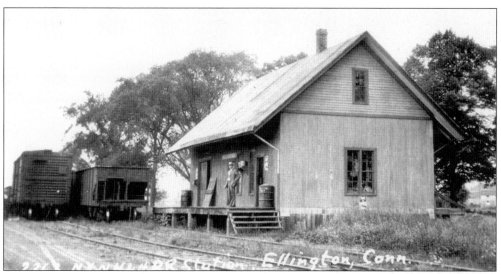

The Connecticut Central Railroad began service to Ellington on October 5, 1876. When Dr. Edwin T. Davis brought his bride to their new home on Main Street in June 1892, Dora Kibbe and other local ladies peeked from behind their parlor curtains as the doctor and his wife walked from this train depot at the corner of Pinney Street and Frog Hollow Road. The depot was removed in the late 1940s. (Courtesy of Archives and Special Collections at the Thomas J. Dodd Research Center, University of Connecticut Libraries.)

In 1875, permission was granted by Connecticut's Railroad Commissioners to build a branch from Melrose to Rockville via Ellington. The line crossed farmland as it ran southeast from Melrose toward the depot at the west end of Main Street. The train picked up passengers at this small wooden shelter in the Sadds Mill section of town. Passenger trains were allowed to travel at only 20 miles per hour. (Courtesy of Archives and Special Collections at the Thomas J. Dodd Research Center, University of Connecticut Libraries.)

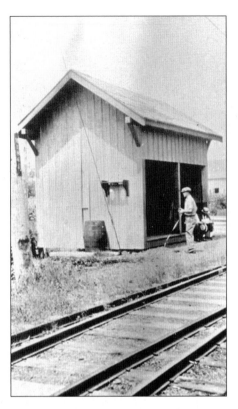

In the late 1890s, the railroad was leased to the New York, New Haven, and Hartford Railroad. The train picked up passengers at this flag stop in the Windermere section of town. Passenger service ended in 1914 as a result of competition from street railway and automobiles. The trolleys used the railroad tracks, which were electrified by overhead catenary wires. (Courtesy of Archives and Special Collections at the Thomas J. Dodd Research Center, University of Connecticut Libraries.)

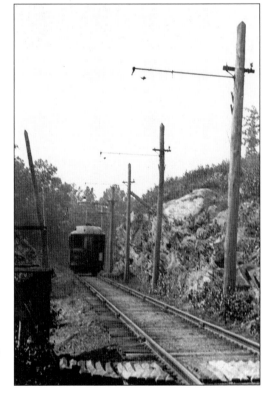

In the early 1900s, a trolley ran from Hartford to Springfield by way of Manchester, Rockville, Ellington, and Warehouse Point. The Rockville branch opened to the public on May 20, 1906. Fares were 5¢ per zone. From West Street in Rockville, the line ran along Route 83, where it turned west onto Main Street at the present Kloter Farms. The last trolley passed through Ellington Center on July 1, 1926.

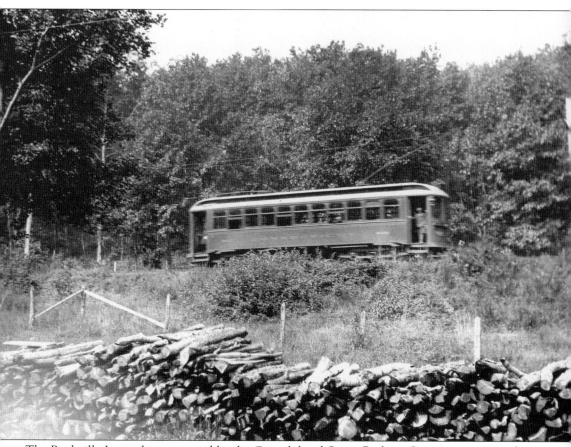

The Rockville Interurban, operated by the Consolidated Street Railway Company, connected Rockville to Stafford in 1908. Passengers from Ellington and Stafford could make connections to Hartford from Rockville. The Stafford extension left Rockville's Market Street depot and passed by Amerbelle Corporation on East Main Street before heading north on Grove Street toward the eastern shore of Shenipsit Lake and West's Bridge. It continued along the present Route 30 past Crystal Lake on its way toward West Stafford. From there it turned east, passing south of today's Stafford Speedway before it reached its destination just beyond the railroad station in Stafford. Service was gradually cut back until buses replaced all trolley service on April 27, 1931.

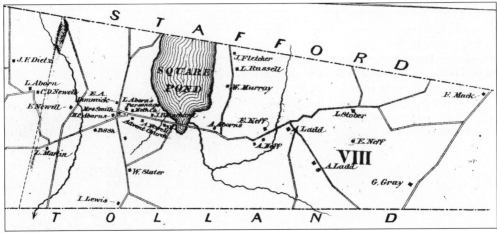

Crystal Lake was called "Wabbaquasset" by the ancient Nipmuc tribe and "Square Pond" by early settlers. A triangular strip of land between Tolland and Stafford, bounded on the east by the Willimantic River, was added to the already granted township of Ellington at its northeastern corner. Called the "Equivolent," it settled a land dispute. The name was officially changed to Crystal Lake in 1889, 20 years after this map was drawn.

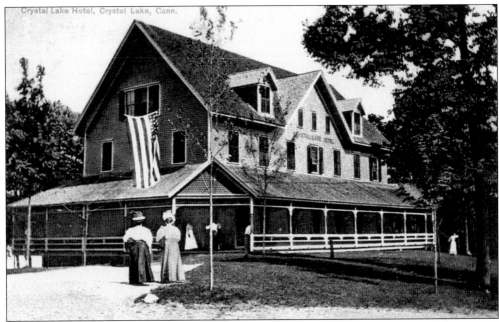

The Crystal Lake Hotel was built on the west shore of the lake in 1890, just south of the present State of Connecticut public boat launch. It was a popular summer resort with bath houses and a dance pavilion operated by proprietor William Bowler. The hotel was damaged by a fire in 1935, which was one of the first fought by Crystal Lake Volunteer Fire Company No. 2.

Ada Morrell Meyer holds her three-and-a-half-year-old niece, Marian Kent, at Crystal Lake in 1920. Ada's bathing costume has a knee-length gored skirt with a striped sailor collar, striped trim, and a modesty bib. Ada emigrated from England where women did not wear the black stockings which American ladies wore for decency in mixed bathing. A swim bonnet completes the costume.

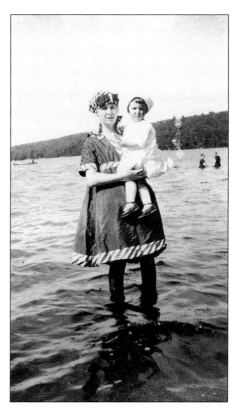

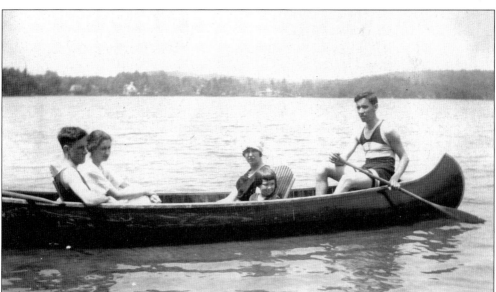

In the early 1900s, Crystal Lake was developing into a summer resort community. The interurban trolley brought day trippers for swimming, picnicking, and boating. Summer cottages were built along the shore and nearby hills. The lake was placid on this summer day in 1920 when Reginald Kent paddled a canoe with, from left to right, William Butcher, his fiancée Bessie Morrell, Bessie's sister Ada Morrell Meyer, and Kent's daughter Marian.

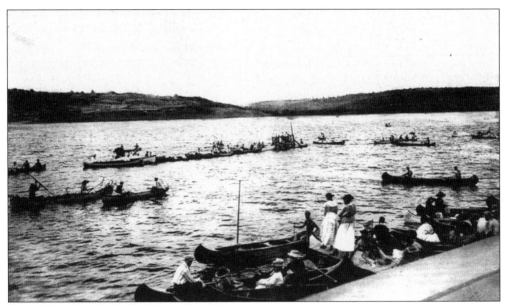

Men and women, dressed rather formally by today's standards, came on the interurban trolley or from nearby rented summer cottages for a Canoe Carnival at Crystal Lake. This postcard was printed in France c. 1915. Up until the start of World War I, most post cards were printed in Germany, which used high quality lithographic processes. This white border–style postcard saved ink.

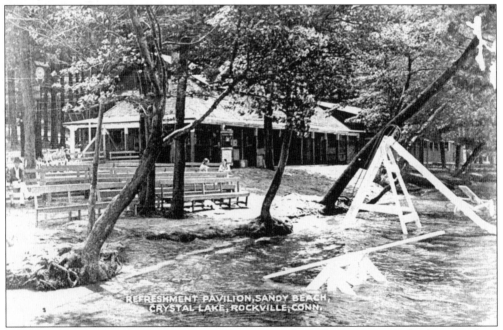

Sandy Beach on Crystal Lake was part of the Lucius Aborn farm. George Bokis leased it from William Bowler, proprietor of the Crystal Lake Hotel, in 1923. After clearing pine trees, he developed a public beach, amusement park, dance hall, penny arcade, and boxing arena. The town of Ellington purchased Sandy Beach in 1971, razed the old buildings, and improved the beach. The town operates beach facilities in the summer.

Gordon and Mildred Arens Dimock pose for the photographer in their fashionable sleeveless jersey athletic tank suits in 1930. The Dimocks and many other young people also enjoyed the evening entertainment at the Sandy Beach Ballroom. Duke Ellington, Guy Lombardo, and Cab Calloway were some of the big name bands that attracted crowds. Mildred was named to the Ellington Wall of Honor in 2005.

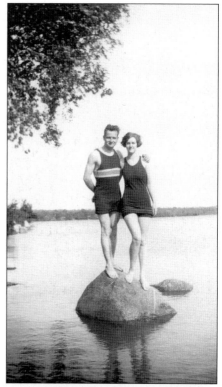

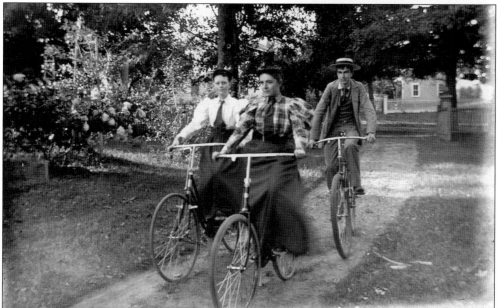

In the early 1890s, bicycling was all the rage. A bicycle enumeration in 1896 showed over 70 wheels within a one-mile radius of Ellington Center. A news items in *The Rockville Journal* noted: "Miss Ida Bancroft has a new wheel which she rides very nicely." This photograph of three unidentified people enjoying the sport was made from a glass plate found in the Cordsten house on Somers Road.

This photograph was taken in August 1923 on Frog Hollow Road looking east toward Main Street at the intersection of Tomoka Avenue and Pinney Street. The house on the left was the home of John DeCarli, named to the Ellington Wall of Honor in 2001. A founder of the Ellington Volunteer Fire Department and Constable from 1915 to 1935, he was killed in the line of duty while attempting to arrest a robbery suspect.

In this pastoral view of Maple Street in August 1923, the Daniel Kimball House can be seen behind the fence on the right. Still standing, it is to the west of Ellington High School. Mr. and Mrs. Kimball moved to this two-story Greek Revival house when they left their former home on Somers Road around 1888. The Kimballs' daughter, Julia, and her husband, John T. McKnight, lived in the west part of the house.

Looking west on Main Street toward Frog Hollow Road, a car approaches the intersection of Pinney Street and Tomoka Avenue on a sunny August day in 1923. The house on the left was the home of John Hall, headmaster of the Ellington School, which was across the street. After the school was destroyed by fire in 1875, the Bancroft house, barely visible through the trees, was built on the site.

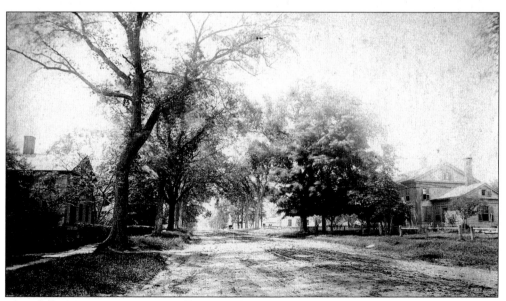

This idyllic Main Street scene recalls a time when country sounds were roosters greeting the day, the clip-clop of horses' hoofs on sandy gravel, and the rattle of farm wagons and buggies. Voices of men on the steps of the village store mingled with metallic sounds from the blacksmith's shop. The Thomas Chapman house on the left was built in 1831 and the Rev. George Mixter house on the right, in 1842.

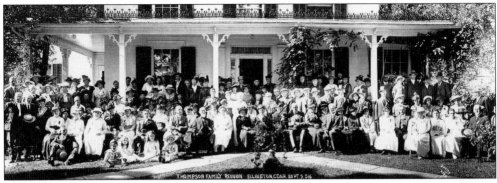

The Thompson family gathered for a reunion on September 9, 1916, at the family homestead on the Ellington-Melrose town line. John Thompson, a well-known agriculturist in Ellington, and his wife, Anna Ellsworth, had nine children, including the Honorable John Thompson, born in 1840. John was a veteran of the Civil War, and president of the Ellington Creamery, established in 1884.

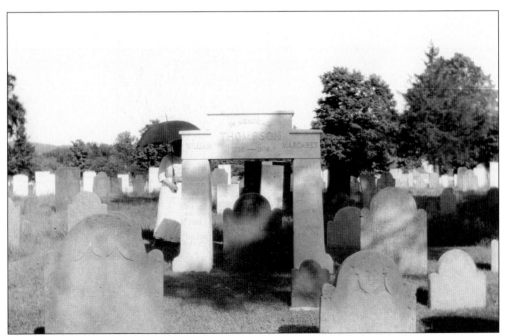

A lovely lady in white stops at the monument erected in the Ellington Center Cemetery to honor William and Margaret Thompson and their nine children. The family left Scotland in 1716 and remained in Ireland for a year. William died there, but had urged them to continue their journey to America. The tombstone under the arch marks the grave of Margaret, who died in 1752 at the age of 87.

*Six*

# VILLAGE MEETING HOUSES

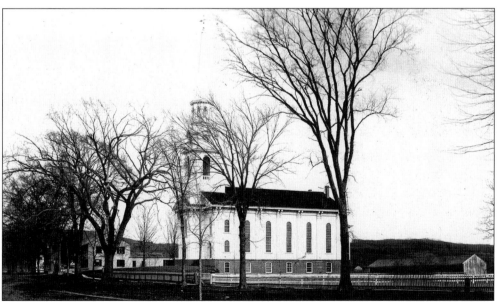

The third meeting house of the Congregational Church is pictured prior to 1884, when a house was built in the location of the fenced area west of the church. The house which is now the Nellie McKnight Museum, pictured before an ell was removed, is in the background. The horse sheds at the right were used by those who arrived at church by way of horse and buggy.

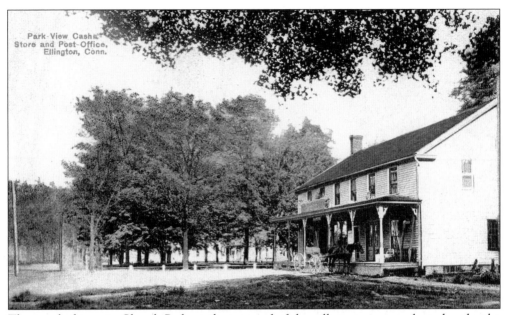

The stand of trees in Church Park, at the east end of the village green was planted under the supervision of the ninth pastor of the Congregational Church, the Rev. Nathaniel Eggleston, in the late 1840s. The skinny trees were referred to as "Eggleston's woods." The low iron and granite fence was added by the Village Improvement Society *c.* 1875, and by the early 1890s the park was a shady grove.

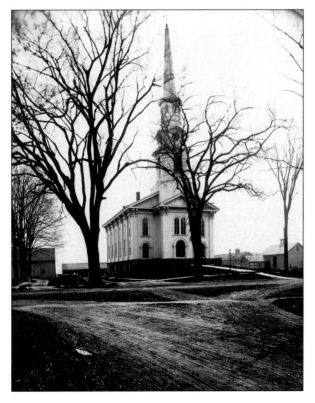

The third meeting house of the Ellington Congregational Church was built in 1867 and 1868. Wider and longer than the present, fourth meeting house, the third church's tall, white spire reached 165 feet in height. The town hall and selectmen's room were housed in the brick basement. The main floor was four feet higher than the present church, and reached by a steep slope from the street.

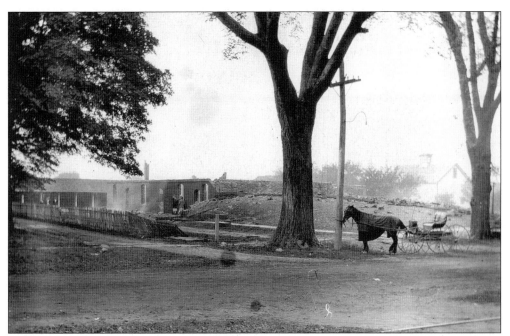

Smoke rises from the ruins of the third church building of the Ellington Congregational Church. Completed in 1868, it stood opposite the site of the second church. The town hall was in the basement, and when an arsonist set the building ablaze on Saturday October 3, 1914, the church and its entire contents were destroyed.

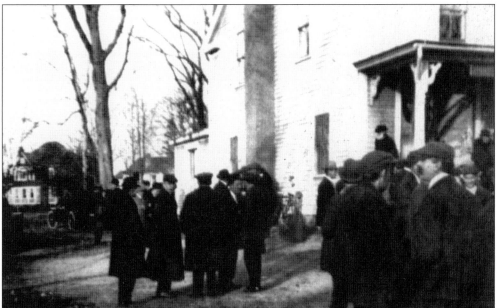

Voters gather around Francis Charter's Parkview Cash Grocery on the morning of Monday, October 3, 1914. The third meeting house of the Congregational Church had burned to the ground on Saturday night. The town hall had been in the basement of the church. Town records state that the town meeting was convened at the site of the burned building and adjourned to the horse sheds in the rear.

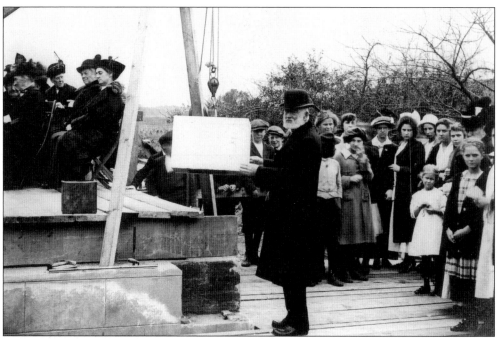

This picture was taken at the exercises held at the laying of the cornerstone of the fourth meeting house of the Congregational Church on October 7, 1915. Eighty-nine-year-old Stephen I. Johnson, a masonry expert and member of the church, is shown with the cornerstone. One of the women standing in the group at the right is Mildred Charter.

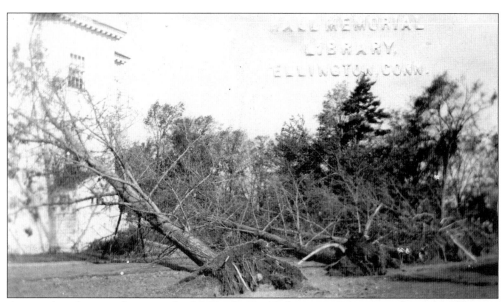

A row of poplar trees between the McKnight Family home and the east side of the Ellington Congregational Church could not withstand the ferocious winds of a hurricane on September 21, 1938. Many other full-grown trees on Main Street were broken off or uprooted.

It was after the third building burned in 1914 that the Church voted to incorporate as the Ellington Congregational Church. Business that had previously been in the hands of the Congregational Ecclesiastical Society of Ellington was turned over to trustees. The present church, pictured here on January 26, 1940, was dedicated on August 17, 1916. It was designed in the Colonial Revival style by architects Clark and Arms of New York.

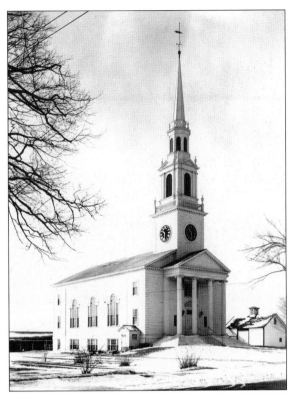

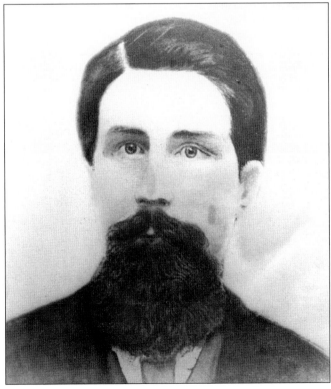

The Rev. Henry Weston Smith was born in Ellington in 1827. He served in the Civil War and became the first Christian minister to enter the Black Hills after the discovery of gold. After preaching in Deadwood on August 20, 1876, he headed to Crook City to preach. He was shot and killed in an ambush, and the undelivered blood-stained sermon was found in his pocket. (Courtesy of Adams Museum, Deadwood, South Dakota.)

# ❧ MAY BREAKFAST ❧

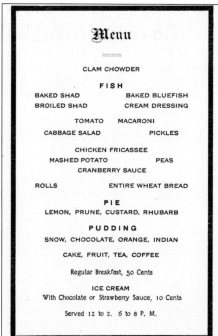

## ELLINGTON, CONNECTICUT

The social life of the members of the Ellington Congregational Church centered within its walls: Sunday services, Thursday night prayer meetings, choir rehearsals, fairs, and suppers. This invitation is for the 1910 annual May Breakfast, an all-day event timed to take place when shad were running in the Connecticut River. There are about 1300 bones in an adult shad, so preparing this bony fish for a group was not an easy task!

### Menu

CLAM CHOWDER

**FISH**

| | |
|---|---|
| BAKED SHAD | BAKED BLUEFISH |
| BROILED SHAD | CREAM DRESSING |

TOMATO    MACARONI

CABBAGE SALAD           PICKLES

CHICKEN FRICASSEE

MASHED POTATO           PEAS

CRANBERRY SAUCE

ROLLS           ENTIRE WHEAT BREAD

**PIE**

LEMON, PRUNE, CUSTARD, RHUBARB

**PUDDING**

SNOW, CHOCOLATE, ORANGE, INDIAN

CAKE, FRUIT, TEA, COFFEE

Regular Breakfast, 50 Cents

ICE CREAM

With Chocolate or Strawberry Sauce, 10 Cents

Served 12 to 2.    6 to 8 P. M.

The favorite entrée at the annual May Breakfast was always baked or broiled shad. The price of this breakfast was 50¢, and for an extra 10¢ you could have ice cream with chocolate or strawberry sauce. All church members helped in this fund-raising event, with the men setting up the tables in the church parlors, waiting tables, washing dishes, and running errands for the ladies.

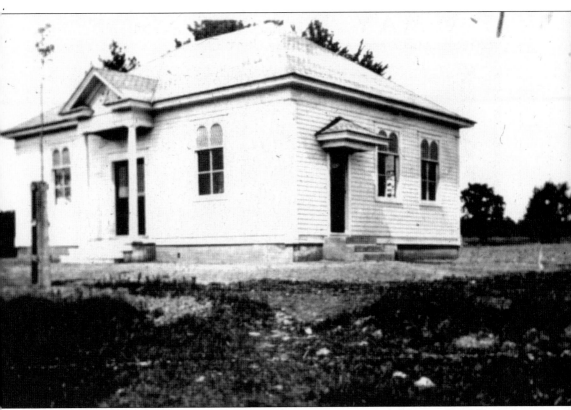

The synagogue pictured here was built in 1913 on the southeast corner of Abbott and Middle Roads on land donated by Julius and Molly Sugarman. It was moved to its present site and renovated at 236 Pinney Street in 1954. The land was donated by Eva and Calmun Myerowitz. Congregation Knesseth Israel had its origins in the Connecticut Jewish Farmers Association, which was organized in 1905. Loans granted by the Jewish Agricultural Society to European immigrants enabled them to buy land and farm in Ellington. Before the synagogue was built, the farmers met in the homes of Aaron Dobkin, Samuel Rosenberg, and Louis Franklin for Sabbath services.

The history of the Apostolic Christian Church on Middle Butcher Road began when Mrs. John Kloter, "Mother Kloter," and her children emigrated from canton Zurich, Switzerland, in 1869 following the death of her husband. Early Swiss emigrants worked as silk weavers, as they did in their native land, but later turned to farming. The congregation built this church in 1954 and moved from their previous location on Orchard Street in Rockville.

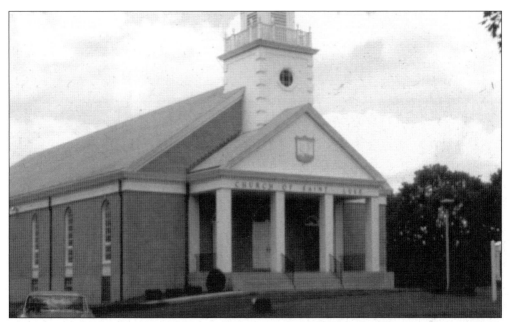

This photograph of the Church of Saint Luke was taken in 1962. As Ellington grew, Catholic families wanted their own church. They petitioned the Bishop of the Diocese of Norwich to establish a church in town. The Rev. Maurice Sullivan was appointed the first pastor in March 1961, and the first Sunday masses were held at Ellington High School. Groundbreaking was in April 1962 and the church was dedicated in December 1962.

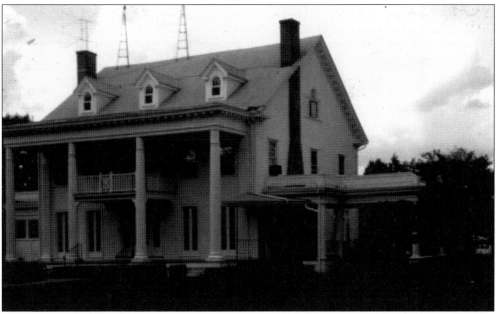

The Church of Saint Luke is a contemporary brick interpretation of Colonial Revival designed by architect Arthur E. Thomas of Norwich. In 1961, the Church of Saint Luke purchased the Colonial Revival frame house next door on Maple Street, built in 1916 by Miles H. Aborn, from the estate of George Wendhiser for use as a rectory.

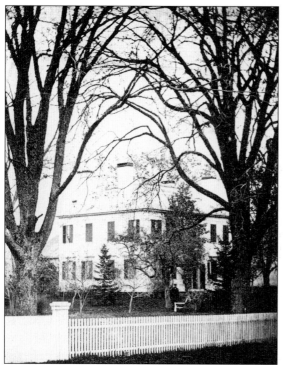

The Rev. Diodate Brockway was ordained as minister of the Congregational Church in 1799 and served until 1849. The Brockway House on Main Street, east of the old Center School, later was the home of James Morris Talcott and his wife, Julia Belden Talcott. Julia escaped safely when the house was destroyed by fire in 1914 at the hands of the same arsonist who destroyed the third Congregational meeting house.

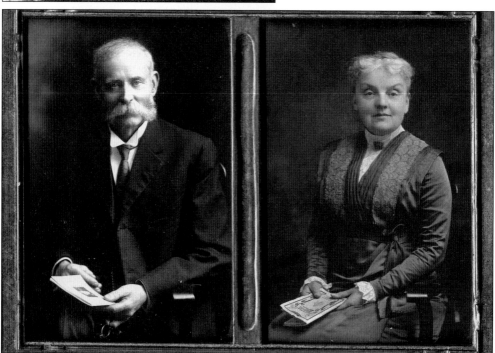

The Rev. David Jones was the 19th pastor of the Congregational Church, from 1898 to 1917. Born in Wales, he was a graduate of Yale Divinity School. He and his wife Emma, pictured here, lived in the first parsonage owned by the Church. It was the home of Sarah Gilbert, who left her Greek Revival–style home at 89 Maple Street to the Church in her will in 1898.

*Seven*

# VILLAGE SCHOOLS

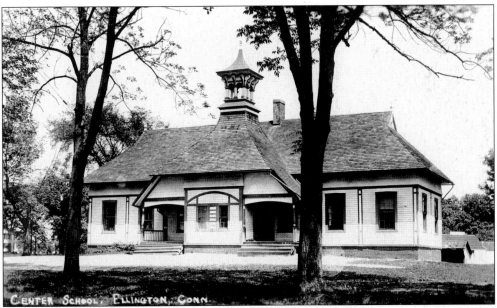

This two-room District School No. 6, Center School, stood until it was dismantled in 1949, and the present school was built on Main Street just to the east. At that time five districts were consolidated in the new brick school. In 1931, a young teacher remembers teaching 42 students in the combined seventh and eighth grades. Another teacher taught first, second, and third, while a third taught fourth, fifth, and sixth grades.

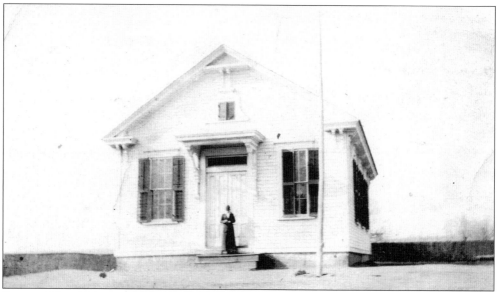

District School No. 3 was the Job's Hill School. Pictured is the schoolhouse that was built in 1873. At the beginning of the 20th century, water came from a pump in the school yard. On cold mornings, the teacher built a fire in the stove. The teacher may have just graduated from the school herself, since a teaching certificate could be earned by a six-week summer course in Normal School.

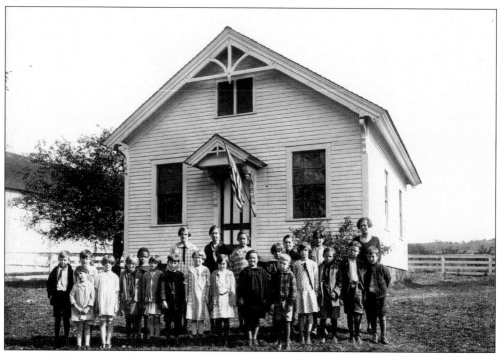

District School No. 5 was the Kimball School. The original school was built in 1798 on Somers Road near Maple Street. This one-room schoolhouse, pictured *c.* 1927, was built in 1891 on Kimball land on the east side of Somers Road. When auctioned off with four other schools in 1949, it sold in ten minutes for $3,600. The successful bidder converted it into a private home.

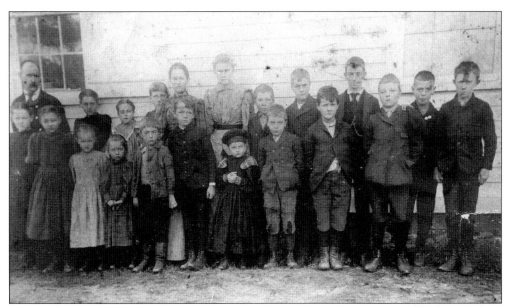

District School No. 8 was the Crystal Lake School at the corner of White Road and Sandy Beach Road. It was built in 1861 and this photograph was taken in 1896 when Myron Dimock was the teacher. From left to right are (first row) Elna Dimock, Flossie Baker, Bernice Dimock, Emma Carlson, Arthur Kibbe, Raymond Willis, Ora Charter, Claude Dimock, Everett Charter, Julius Richardson, and Bill Sullivan; (second row) Myron Dimock, Lena Dimock, Bessie Neff, Myrtie Willis, Edna Dimock, Bessie Richardson, Clarence Newell, Everett Kibbe, and Earl Curtis.

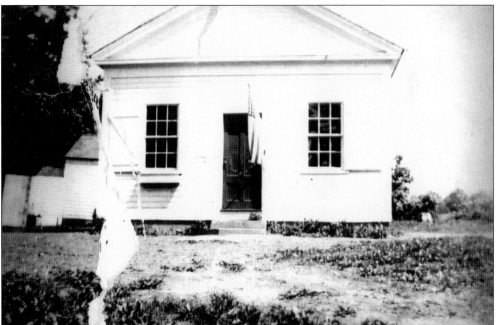

District School No. 9 was the Frog Hollow School, so named because the one-room schoolhouse was built in 1824 on the north side of Frog Hollow Road just east of a frog pond. It was moved further west to higher ground in 1860. A picket fence enclosed the new property, and a woodshed was added. An outhouse, or "necessary," stood next to the shed. The school closed in 1945.

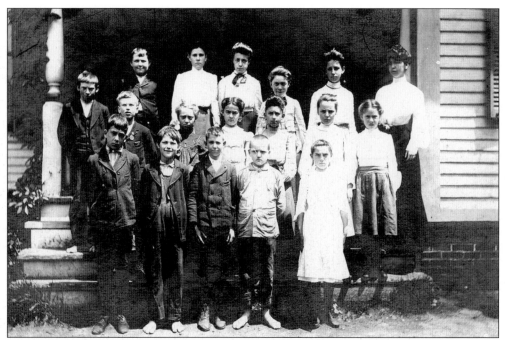

Iva Price is one of the older girls in the last row of students at the Center School in this photograph taken on June 13, 1905. Her teacher, Bessie H. Codaire, is dressed in the style popular at the beginning of the 20th century. First sketched by Charles Dana Gibson in 1902, the characteristic soft pompadour hairdo of the Gibson Girl look would last a quarter of a century.

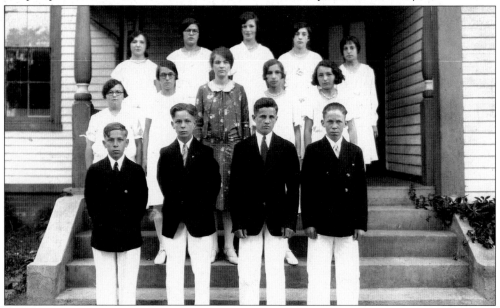

The eighth grade class of 1930 at Center School looks smart for its graduation picture. Seen here are, from left to right, (first row) Andy Gale, Frank Dowd, Louis DeCarli, and Bud Kelly; (second row) Charlotte Dimock, Martha Stutz, Mrs. Lydia Ladd, Hannah Miller, and Laura Peck; (third row) Ida Yazmer, Helen DeCarli, Mabel Hepton, Mary Goldfarb, and Rose Schanal. Mrs. Ladd and another teacher boarded with Arthur and Mary Hale on Main Street.

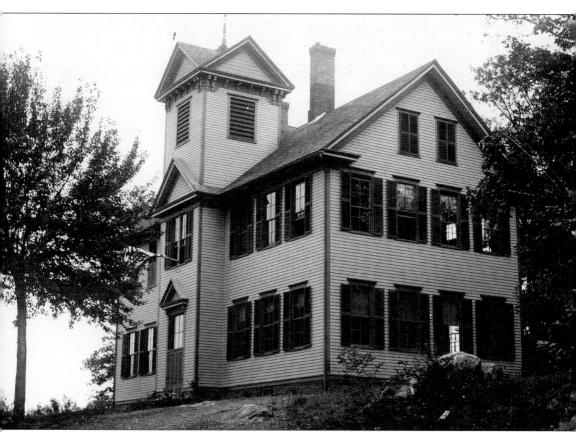

District School No. 10, Longview School, was built in 1894 on North Park Street on land given by Nathan Doane. Students had to follow a path through Doane's Grove to reach the school until a road was put through in 1895 connecting it to Upper Butcher Road. Larger than the other district schools, there were eight grades in four large rooms with high ceilings. Mr. and Mrs. Paul Lanz prepared hot lunches in their home for the students in 1950. After the Longview Middle School was built on Middle Butcher Road in 1954, the old school was called the Longview Annex and used as the school administration building. It burned down on October 4, 1971.

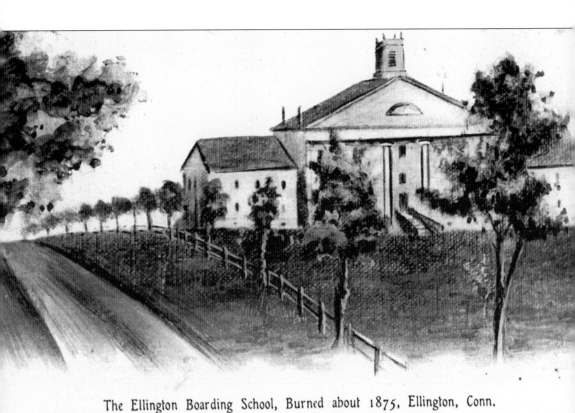

The Ellington Boarding School, Burned about 1875, Ellington, Conn.

The Ellington School was erected on a gentle rise on Frog Hollow Road, west of the village, facing east. It opened in the fall of 1829 with John Hall as principal. For ten years it was a private boarding school for boys and came to be regarded as one of the foremost classical schools in the country. When Hall's health forced him to resign, the school became more of a village academy, and girls were accepted. Most of the teachers were Yale graduates, including Alphonso Taft, father of Pres. William Howard Taft. The school closed in 1870, and was destroyed by fire in October 1875.

Frederick Law Olmsted Sr. is listed as a student in this *Catalogue of the Officers and Students of the Ellington School for the year 1845.* He did not stay long at the school as he moved from place to place gathering experience and skills, which he ultimately used in the new profession of landscape architecture. In the catalog, the village of Ellington is described as "quiet and healthful and finely situated." Perhaps his time in our quiet village contributed to his belief in the restorative value of the landscape, and its ability to improve the quality of life. His designs of large urban parks such as Central Park in New York City were intended to relieve the stress of urban life.

| NAMES. | RESIDENCE. |
|---|---|
| Charles T. Hayden, | *Warehouse Point.* |
| Leander Hamilton, | *Ellington.* |
| Henry Huntington, | *Mansfield.* |
| Joseph Hull, | *East Windsor.* |
| Leander Hotchkiss, | *Windsor Locks.* |
| Julius E. Johnson, | *Rockville.* |
| Judson Jaques, | *Vernon.* |
| Joseph Lyman, | *East Hampton, Mass.* |
| Daniel Kibbee, | *Ellington.* |
| Carlos Kimball, | " |
| John Kelly, | *Mansfield.* |
| Edwin Kellogg, | *Ellington.* |
| Edwin Lathrop, | " |
| Moses C. Lathrop, | " |
| James Loomis, | *West Windsor.* |
| Henry Ladd, | *Ellington.* |
| Edward V. Moseley, | *Springfield, Mass.* |
| Edward Mather, | *Windsor Locks.* |
| Alfred Mather, | " |
| George Marsh, | *Hartford.* |
| Joseph Morris, | *Ellington.* |
| James McKnight, | " |
| Edward Manning, | *Lebanon.* |
| Maddison Mixter, | *Ellington.* |
| Timothy Nash, | " |
| George F. Orcutt, | *Hartford,* |
| Frederick Olmsted, | *Ellington.* |
| E. R. Paul, | *St. Thomas, Canada West.* |
| Henry Pease, | *Ellington.* |
| Ellsworth N. Phelps, | *West Windsor.* |
| Charles Perrin, | *Vernon.* |

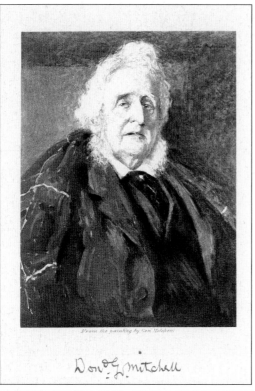

*From the painting by Geo Melchers*

Don G. mitchell

Donald Grant Mitchell attended the Ellington School in the late 1830s and continued his education at Yale, from which he graduated in 1841. He became a household name as a writer of popular essays published under the pseudonym "Ik Marvel." The best known were *Reveries of a Bachelor* and *Dream Life*. The hero of his only novel, *Dr. Johns*, was said to have been Headmaster John Hall of the Ellington School.

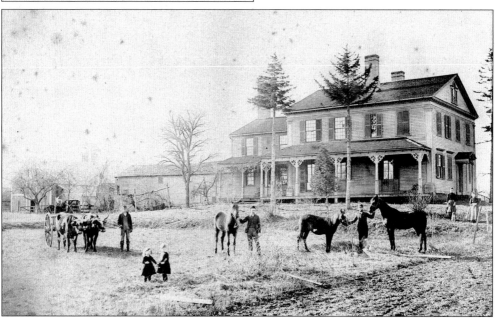

An undated photograph shows Judge John Hall's house on the south side of Frog Hollow Road. Four years before he incorporated the Ellington school, he founded a coeducational academy primarily to educate his growing family. He and his first wife, Sophia Kingsbury Hall, had eleven children. He had five more from his second marriage. Judge Hall was also the author of several readers used in schools in the United States.

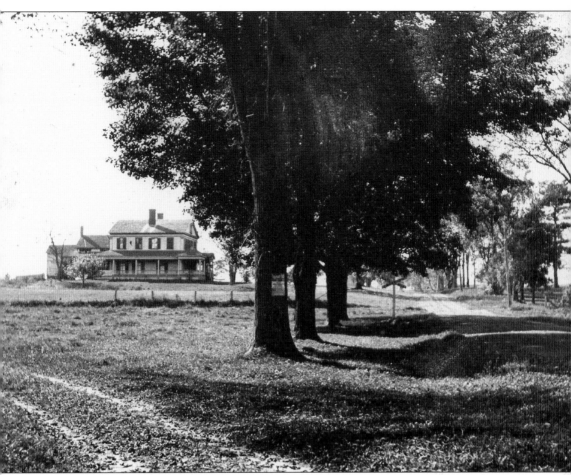

In *Reveries of a Bachelor*, Donald Mitchell reminisced about marching down this country road from the Ellington School in procession to the village church on Sundays. Headmaster John Hall's house on Frog Hollow Road, seen here, was across the street from the school. Mitchell remembered country women who wore stiff bonnets and ate fennel. He and his friends liked one black-eyed girl named Jane, and another named Sophia, who, in the winter, wore a fur-trimmed hat. "Half the boys in the school said they would marry her some day or other." Once a week Mitchell had spending money, and he and the other boys would "go down to the village store and club our funds together to make great pitchers of lemonade." Sometimes hostilities threatened between the school and village boys, the champions being a "hatter's apprentice and a thick-set fellow who worked in a tannery." Years later, Mitchell visited Ellington and found that the playground had been plowed to plant corn, and an apple tree with a low limb that had served as their gymnasium had been cut down.

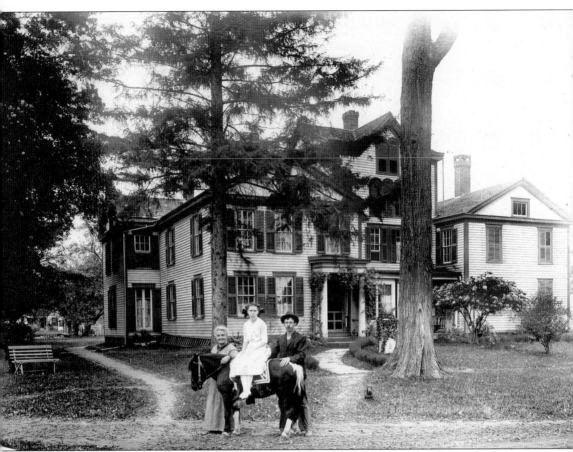

Edward Hall's Family School for Boys is now an apartment house at the corner of Main Street and Berr Avenue. Established in 1844 by the eldest son of John Hall, founder of the Ellington School, the building was expanded as the school grew. It originally consisted of what is now the western part with an ell extending eastward. This section was duplicated on the east side and joined by a higher central section of Greek Revival style. The school was purchased in 1891 from Edward Hall's widow and daughter by Theodore C. F. Berr, a blacksmith. Pictured here around 1905 are Berr's wife, Samantha, youngest daughter, Emma (on the pony), and the Berr's eldest son, Gustave. Berr Avenue, which extends from Main Street north to Maple Street, was formerly known as Mechanic Street, a street where several tradesmen had shops.

In this view of Edward Hall's Family School for Boys, the boys and their teachers strike a casual pose on the grounds of the school on Main Street c. 1860. Classes of about 12 students stayed from three to five years, living in a family setting with a matron and teachers as well as the principal, Mr. Hall. Classics were emphasized, and in 1860, three of the teachers taught Latin.

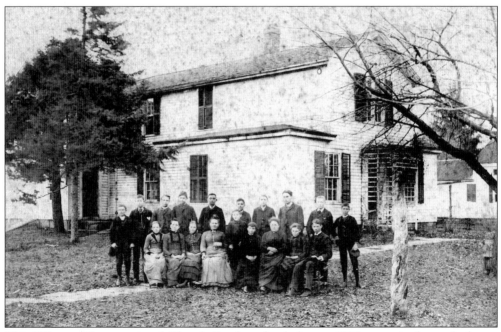

This Ellington Congregational Church Sunday school class, c. 1890, poses in front of a house at 105 Main Street that had formerly contained classrooms and a gymnasium for Edward Hall's Family School for Boys next door. Fourth from the left in the front row is the teacher, Mrs. Pease. The boy behind her may be Emory Thompson. Third from left in the front row is Lizzie Kibbe.

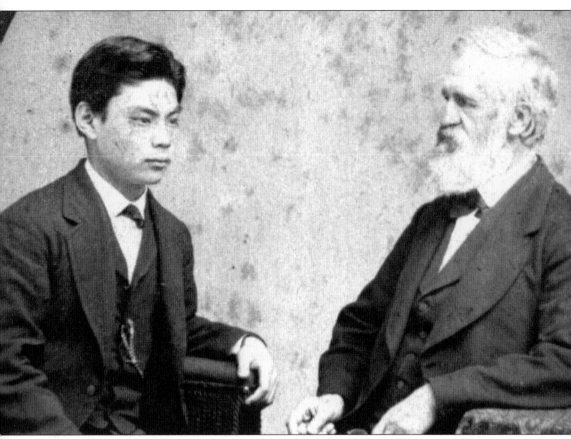

Yanosuke Iwasaki of Japan was a student of Edward Hall, headmaster of Ellington's Hall Family School for Boys in the early 1870s. Living with the headmaster's family was a wonderful opportunity for him to learn English. After the death of his brother Yataro in 1885, Yanosuke became the second president of the Mitsubishi Company. Originally a shipping company, it was under Yanosuke's direction that the company modernized and began its path of diversification that continues today. By 1901, he had become the most prominent figure in industrial Japan and took over management of the National Bank. Yanosuke represented the business community in the Imperial Assembly. The prime minister recommended him for the post of governor-general of the Bank of Japan, where he oversaw Japan's changeover to the gold standard. He passed away in 1908 at the age of 57 in his Tokyo home.

*Eight*

# VILLAGE BUSINESS

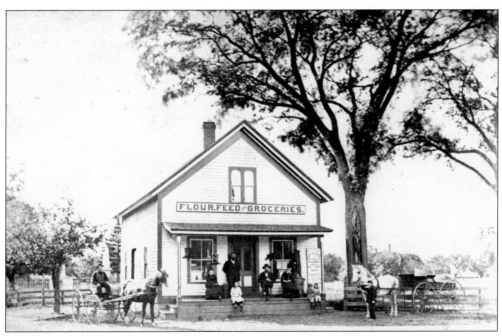

The Chauncey Chapman store is pictured here in 1881. Charles Price, a store clerk, is seated in the wagon at the left. Chapman is standing on the porch. The sign in front advertises flour, butter, cheese, lard, beef, and hams. The store was destroyed by fire, and the land purchased by Francis Hall of Elmira, New York, in 1900 as the site for the Hall Memorial Library.

In this undated photograph are a blacksmith's shop on the left, and a wagon shop on the right on the south side of Main Street. In 1860, the shops were owned by master wagon-maker Thomas W. Chapman Jr. and blacksmith Thomas Bottomley. Theodore C. F. Berr bought the blacksmith shop in 1879. He came to this country from Prussia in 1864 and first worked as a weaver in the Rockville mills.

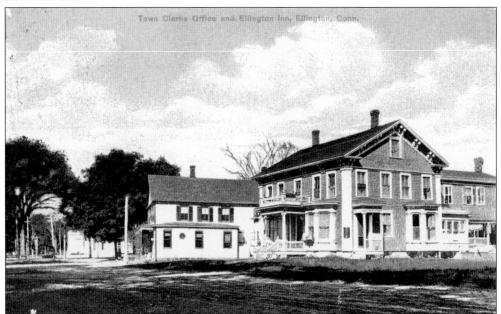

This postcard view of the H. C. Aborn and Son Store and the Ellington Inn was taken after 1907 when electric lights came to the residents of Ellington. The town clerk's office was in the east part of the store. In 1914, a bell was placed on the upper porch to be rung in case of fire. The bell was given by H. C. Aborn and hung by Gus Berr.

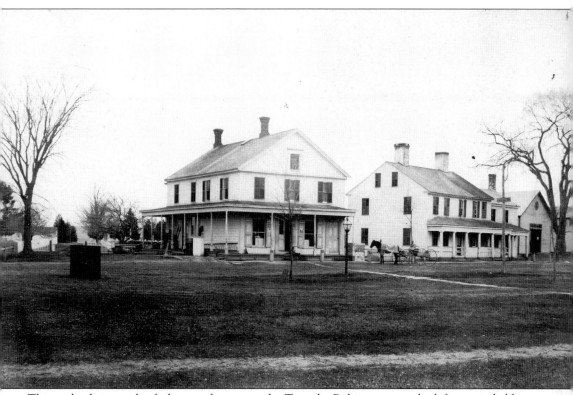

This early photograph of what was known as the Timothy Pitkin store on the left was probably taken before the store was purchased by Henry Aborn in 1884. The Ellington Center Cemetery can be seen to the left of the store behind the watering tub. To the right of the store is the Franklin House. It was built in the 1820s, and its first proprietor was William L. Ransom, a Vernon native. The east part of the hotel was added by Henry Gunn of Springfield, who became the proprietor in 1847. Gunn ran a tavern there for about 30 years until the 1870s. Edward O'Neil was the owner when the Franklin House burned on November 3, 1907. The surrounding buildings were saved by a drenching rain and a bucket brigade. A long ladder reached the roof of the Aborn store, where a volunteer doused the roof with buckets of water. The hotel barn, to the right of the hotel in this photograph, was also saved although the wood was scorched.

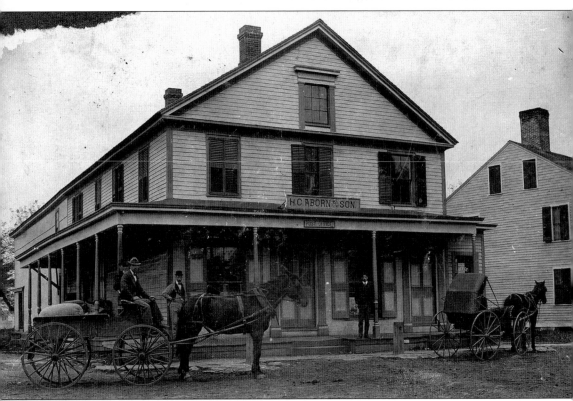

This two-story frame Greek Revival–style general store with an added wraparound Colonial Revival porch was built in the early 19th century. The store has signs in this photograph, "H. C. Aborn and Son" and "Post Office." The Ellington Center post office moved frequently from its establishment in 1822. It was located in homes, taverns, inns, and stores. Pictured in front of the store around 1900 are, from left to right, Alonzo Peck, Horace Sykes, Marshall Charter, and Ernest Bancroft. The barn behind the store served as a grain warehouse, a bleach house, and an ice house. The old store was sold to William and Blanche Fournier in 1939, who remodeled it into a home. Blanche later conducted an antiques business, The Old Store, on the first floor. When Blanche's sister, Corrine Tilden, inherited the property in 1978, it again became a private home.

This view of the Park View Cash Grocery in the foreground shows the trolley passing by after a snowfall on Sunday, April 7, 1911. For several years, the post office was in the grocery, which stood at the corner of Main and Church Streets. The grocery was operated by Francis "Frank" Charter, who was also the postmaster. It carried staples such as flour, salt, and sugar. Some housewives could not get to town easily to shop. Early in the week, Marshall Charter, a clerk in the store, drove around to their houses to take orders, which he delivered toward the end of the week.

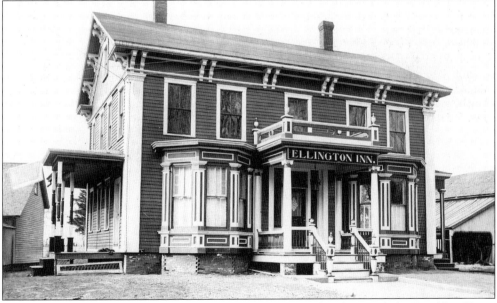

The Ellington Inn was built in Rockville in 1843. After a fire destroyed the Franklin House owned by Edward O'Neil on Maple Street, this building was moved in 1908 from Rockville to the site in Ellington where it remains. It was operated as a hotel for a number of years before being rented as a dwelling and then converted to apartments after it was sold by the O'Neil heirs in 1937.

# HALLADAY'S
# NEW WIND ENGINE

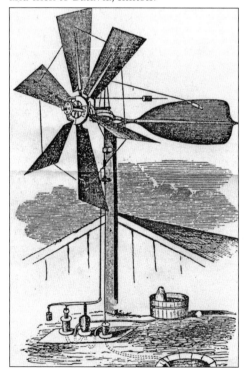

Daniel Halladay is recognized as the inventor of the modern windmill, which is used for pumping well water using wind energy. It was patented in 1854, and was designed and manufactured on the property of blacksmith Albert Dart in Ellington by the newly formed partnership of Hallady, John Burnham Jr., and Henry McCray. The company relocated the next year to South Coventry and then to Batavia, Illinois.

The Halladay Standard windmill model was the first commercially successful windmill in North America. The self-governing design automatically turned to face changing wind directions, and it automatically controlled its own speed of operation so that it did not destroy itself by running too fast. Standard windmills were sold by the thousands to farmers and ranchers on the plains and prairies, pumping water for cattle and irrigation.

The Windemere section was named after Windermere village in the Lake District of England. Windermere Mills and Village were occupied by various manufacturers over the years. They were located on a horseshoe bend of the Hockanum River in the southeast part of Ellington, shown on this 1869 map. The first Windermere School, a brick schoolhouse built around 1812 on the west side of Pinney Street, is marked on the map.

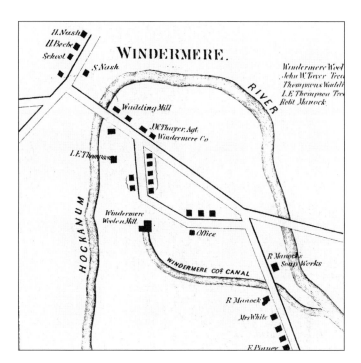

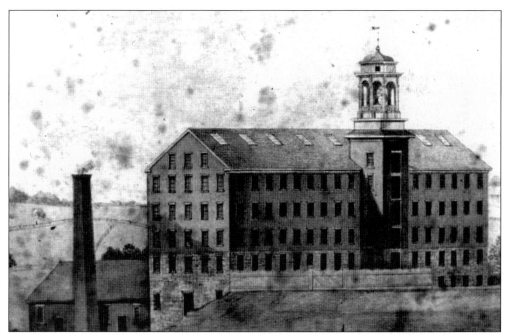

This five-story stone factory was built by Lake Mills in 1849 with a canal leading to it. After it burned to the ground in 1853, it was rebuilt as a three-story brick and stone factory. Business was good during the Civil War, when the mills manufactured woolen army blankets. At its height Windermere Village's 22 acres included a blacksmith shop, machine shop, barn, stable, tenements, store, and factory buildings.

The Ellington Creamery was located on Route 140 just before the curve and rise toward Melrose. The company was organized in February 1884 as a cooperative by a group of area farmers to produce and market butter. At the height of its production, the plant produced several hundred pounds of butter a day. The land and buildings were sold to John DeCarli in 1916, and the plant closed.

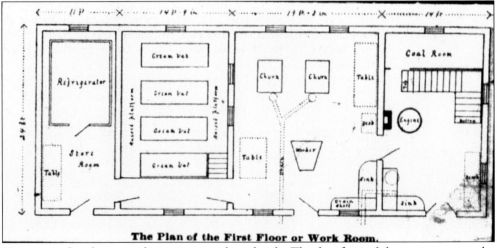

**The Plan of the First Floor or Work Room.**

Upstairs in the plant were living quarters for a family. The first floor of the creamery was the work room. Two churns drained into a pipe that carried the refuse into Creamery Brook. There were four cream vats and a refrigerator to store the finished butter. There was an icehouse at the rear of the building, since electric refrigerators were not in use yet.

## ITEMS FROM ANNUAL REPORT.

### 1901.

| | | |
|---|---|---|
| Total number pounds butter made, | - | 173,342 lbs. |
| Average gross sales per pound, | - | 26 17/100 cts. |
| Total income from sales, | - | $45,098.93 |
| Amount of cream gathered, | - | 778,440 lbs. |
| Average per cent. butter-fat in cream, | - | 17 3/10 per cent. |
| Total amount butter-fat, | - | 134,550 lbs. |
| Average payment per pound butter-fat, | - | 28 18/100 cts. |
| Average expense per pound butter, | - | 4 1/100 cts. |
| Largest amount butter made in any one month—June, | - | 18,259 lbs. |
| Smallest amount butter made in any one month—November, | - | 12,155 lbs. |
| Highest average gross sales—December, | - | 29 68/100 cts. |
| Lowest " " " June, | - | 23 10/100 cts. |
| Largest monthly payment to Patrons, per pound butter-fat—December, | - | 31 cts. |
| Smallest monthly payment to Patrons, per pound butter-fat—May, | - | 24 cts. |

## SUMMARY OF BUSINESS SINCE THE ORGANIZATION OF THE CREAMERY IN 1884.

| | | |
|---|---|---|
| Total number pounds butter made, | - | 3,195,958 lbs. |
| | | (or about 1,598 tons) |
| Total sales, | - | $867,934.93 |
| Distributed to Patrons, | - | $721,607.01 |

### 1901.

#### RECEIPTS.

| | | |
|---|---|---|
| From Sales of Butter, etc., | - | $45,098.93 |
| From Rent of Tenement, | - | 60.00 |
| | | $45,158.93 |

#### DISBURSEMENTS.

| | | |
|---|---|---|
| For Distribution to Patrons, | - | $37,688.03 |
| Paid to Cream Gatherer, | - | 2,506.84 |
| Paid to Butter Makers, | - | 1,095.00 |
| Paid Salary Superintendent, including Delivering Butter, | - | 684.34 |
| Paid Salary Secretary and Treasurer, | - | 100.00 |
| Paid for Express, | - | 1,103.88 |
| Paid for Fuel, | - | 192.28 |
| Paid for Salt, | - | 101.93 |
| Paid for Wrapping Paper, | - | 182.22 |
| Paid for Tubs, | - | 82.54 |
| Paid for Ice, | - | 69.00 |
| Paid for Interest on Stock, | - | 291.00 |
| Paid for Taxes, | - | 27.00 |
| Paid for Insurance, three years, | - | 60.00 |
| Paid for Wagon, | - | 80.00 |
| Paid for New Boiler, | - | 290.00 |
| Paid for Incidental Expenses, | - | 434.87 |
| Added to Reserve Fund, | - | 170.00 |
| | | $45,158.93 |

Respectfully submitted,

D. C. LOVELAND, Supt.

J. T. McKNIGHT, Sec'y and Treas.

ELLINGTON, CONN., Jan. 11, 1902.

The 1901 business statement of the cooperative Ellington Creamery Company show that 1,598 tons of butter had been made since the organization of the creamery in 1884. An employee made daily rounds to farms in a horse-drawn wagon to collect milk or separated cream. Butter was cut into one-pound blocks and wrapped in yellow waxed paper. The blocks were packed in boxes surrounded by ice for delivery.

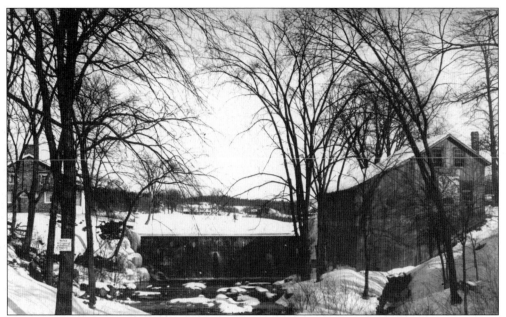

Several mills had existed on the site of Sadds Mill on the Broad Brook. When Roswell Sadd of East Windsor purchased the site in 1867, there was a sawmill and a gristmill. A spring freshet, or flood, washed away the dam and damaged the mills in 1869. Roswell's son, Sumner, took charge of the repaired mills and the rebuilt dam. Mill operations ceased after the end of the 19th century.

The Sadd family is pictured here c. 1915. Matriarch Ellen, seated in the front row and dressed in white, was the daughter of Darius and Parmelia Phillips Crane, and widow of miller Sumner Sadd. The three adults seated in the first row are believed to be Ellen's children, from left to right, Charles, Helena, and Leslie. Third from the left in the back row is believed to be Helena's son, Sumner Abells.

The oldest tavern in Ellington was built in 1767 by John McKnight, formerly of Hartford, who built a small house on his property in the Sadds Mill section. The house was enlarged and had several owners before Timothy Holton bought it in 1781 to use as a tavern. There is a legend that Holton owned a slave who lived in a third floor attic room, still called the Slave Room. John Beasley bought Holton's Tavern in 1822 and it continued to be operated as a tavern until 1838. It remained in the Beasley family for almost a hundred years. It served as the third home of Fayette Lodge No. 69 A.F. and A.M. from 1829 to 1833.

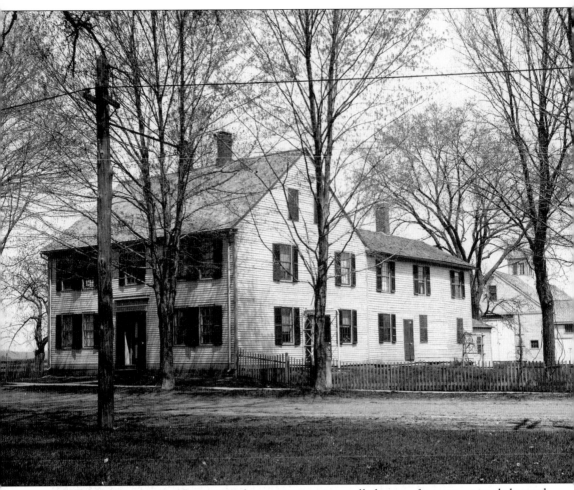

Inns, public houses, or ordinaries, as they were sometimes called, were often conveniently located dwellings on village greens that were remodeled to be used as taverns. This house was used as a tavern for many years. It was known as the Holton Tavern, Pember's Inn, and also as the Fenlow Dow House. Dow owned it from 1864 until his death in 1904. Built in 1791, this two-story frame Colonial building is now an apartment building east of the Church of Saint Luke on Maple Street. It was also the second home of Fayette Lodge No. 69 A.F. and A.M. from 1828 to 1829.

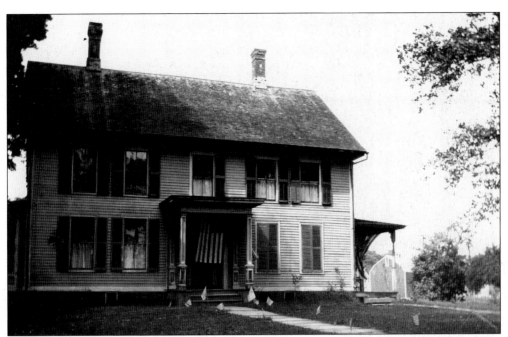

The William Morgan Tavern was located on Main Street opposite the Center School, where Wordcom is now. It was the first home of the Fayette Lodge No. 69 A.F. and A.M. from 1825 to 1828. The tavern's bar room was in the big front room downstairs. The first post office in Ellington Center was established in 1822 in the tavern, with William Morgan as the first postmaster.

Charter's Store and the Ellington post office were located on the site of the present town hall annex. The general store was owned by Edward Charter, and he also served as postmaster from 1940 until his death in 1961. The building was demolished when the Ellington shopping center was built. The first Rural Free Delivery, RFD, route was made by horse and buggy on Saturday August 26, 1903, by Leon Leach.

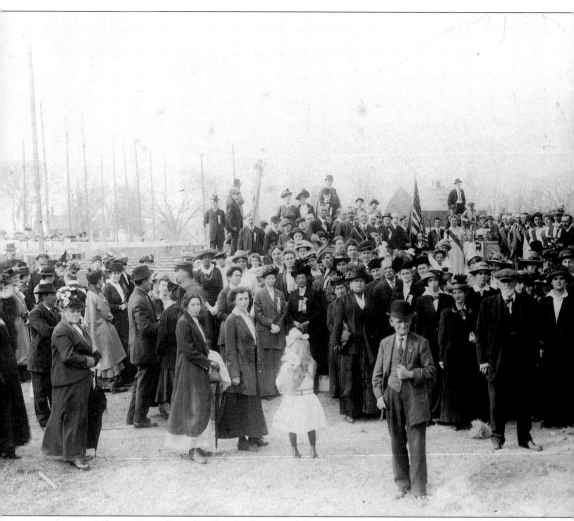

A group of townspeople gather for the laying of the cornerstone of the new town hall on Main Street to the west of Center School on April 24, 1915. The old town hall had been used as a Grange hall since the Ellington Grange was organized in May 1886, so the Grange was invited to conduct the exercises. R. Allen Sikes was the master of ceremonies. The Grange members, headed by the Rockville Fife and Drum Corps and followed by the townspeople, formed a line at the library and marched to the site where the exercises were held on a platform. Town clerk Marshall E. Charter, Rev. David Jones of the Ellington Congregational Church, and architect J. Henry McCray were present. Articles and memorabilia were placed in a box which was then sealed and placed in the cornerstone. After the singing of "America" by the audience, Mary T. P. Wood, lady assistant steward of the Grange, liberated a white dove as an emblematic messenger of love and good fellowship.

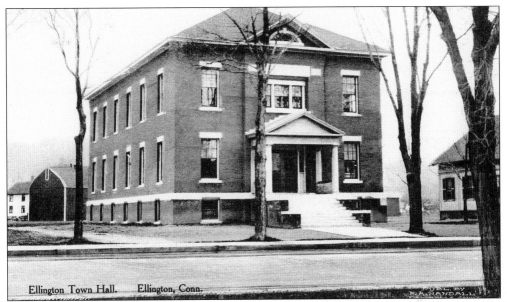

Ellington Town Hall.    Ellington, Conn.

J. Henry McCray was born in Ellington in 1855. After his marriage to Minnie Hare in 1885, he moved to Rockville, where he worked for Belding Brothers and Company in their silk mill. He resigned his position in 1902 to devote his time to architectural work. Among the many buildings he designed were Center School and the Ellington Town Hall, pictured here in this postcard view.

Mail carrier Raymond Morris is pictured here c. 1930 with the car in which he carried the outgoing mail from the Ellington Post Office to Rockville and brought the incoming mail back. Crystal Lake postal service was transferred from Rockville to the Church Street office in Ellington in 1971, but for many years after that some residents in the southeast corner of Ellington continued to have a Rockville postal address.

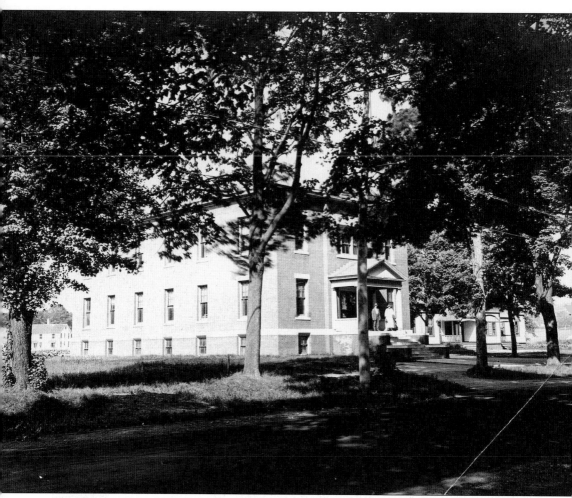

The Ellington Town Hall was built in 1915 and renovated in 1971. When Ellington Congregational Church decided to build its third meeting house in 1867, $5,000 was appropriated by the town to furnish an office for the selectmen in the basement of the new church. In return, the town received the title of the second meeting house, which was sold and moved to Rockville, where it was used as an opera house. After the third meeting house burned in 1914, the town fathers decided to separate Church and Town, and the present town hall was built. It has served other uses as well. From 1921 through 1949, the first floor was used as a schoolroom because of overcrowding at Center School next door, and one of the town's first fire trucks was housed in the basement. Older residents remember watching movies in it. On April 3, 1970, the board of selectmen was authorized at a town meeting to remodel and refurbish the town hall for the needs of a growing town, whose population had reached 8,000.

C. B. Sikes Jr. mows the grass at the Ellington Center Cemetery around 1930.

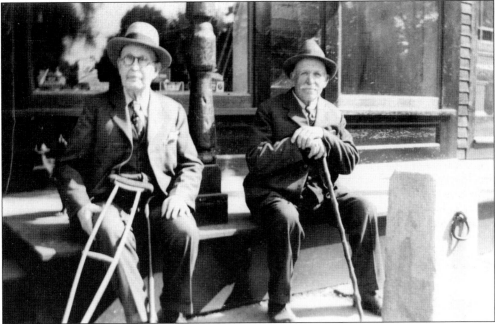

In May 1938, Charles A. Price and Charles B. Sikes Jr. relax on the steps of the general store that Sikes and his son Robert purchased from H. C. Aborn in 1922. Price was the town assessor. He had broken his hip several years earlier, and re-injured it on his way to a setback party. He was helped to the party and insisted on remaining for the game.

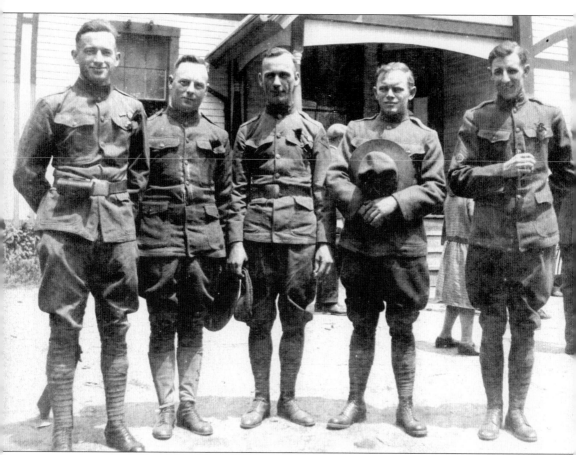

Hatheway-Miller Post 62 was formed after World War I in honor of Sgt. John E. Hatheway and Private William Miller, who were killed in action in 1918. Shown from left to right in this 1920 photograph are charter members Joseph A. McVarish, Harold J. Patric, Wallace W. Bergh, Clyde A. Cordsten, and Carl A. Goehring. The post was responsible for the organization of the Ellington Volunteer Fire Department in 1928, and raised $5,000 for its first truck, a 750-gallon Childs pumper. The first fire chief was Legion member Theodore A. Palmer. That first, used truck was kept for 18 years and housed at the former John DeCarli property at the corner of Main Street and Tomoka Avenue.

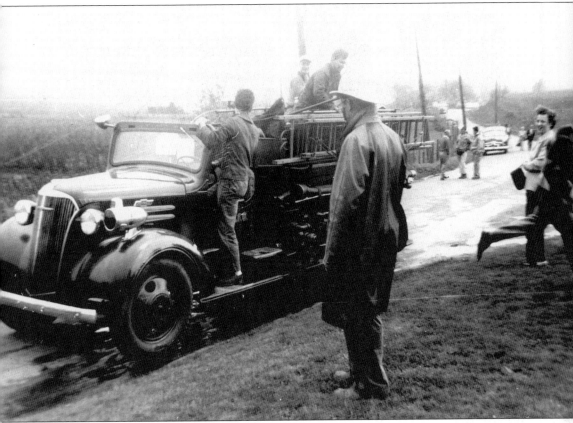

The Ellington Volunteer Fire Department was organized on May 7, 1928, to provide local fire protection. The town had relied in the past on the Broad Brook and Rockville departments. This 1937 Chevrolet truck was new when it was purchased. It was housed in the basement of the town hall. The 400-gallon truck served as back-up pumper for many years and then as the "Brush Truck." It was retired from service in November 1977.

# SNIPSIC ICE CO.
## ICE
### HOWARD C. WEST

Iceboxes were used before homes had refrigerators. Ice was harvested from lakes in the winter, packed in straw and sawdust, and stored in icehouses until it was delivered to customers by horse and wagon. In the early 1900s, Howard West harvested ice from Shenipsit Lake. Notes on the back of this sign record deliveries to Rockville Hospital and private homes. Total receipts that day were $1.70 cash and 20 tickets.

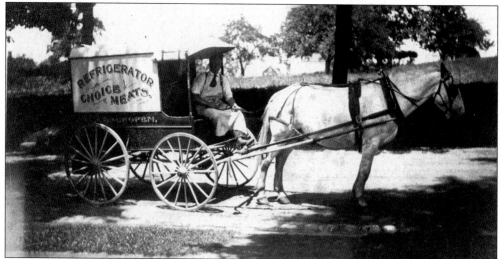

In the days before supermarkets, rural customers depended on home delivery of meats as well as milk. This horse and buggy is from Backofen's Market on Ward Street in Rockville. Sam Cor of Ellington also had a meat truck route. He carried beef, ham, and veal. The women of the Congregational church bought Sam's roasts for their church suppers, and he would come back to slice the meat for them.

# *Nine*

# FARMING

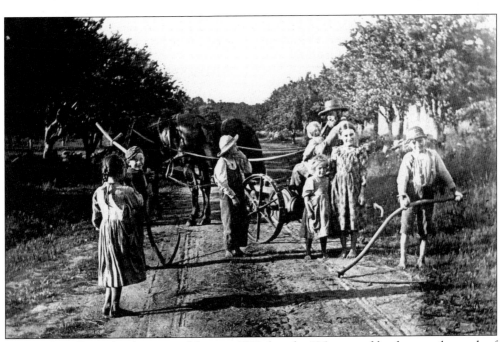

The Fred Hoffman family, pictured here *c.* 1903, bought 125 acres of land one mile north of Ellington Center in 1900. The road is still known as Hoffman Road. Fred and his wife, Eliza, were the children of immigrants of German Swiss descent who came to Tolland County in the late 19th century to work in textile mills, but stayed to farm the rich soil.

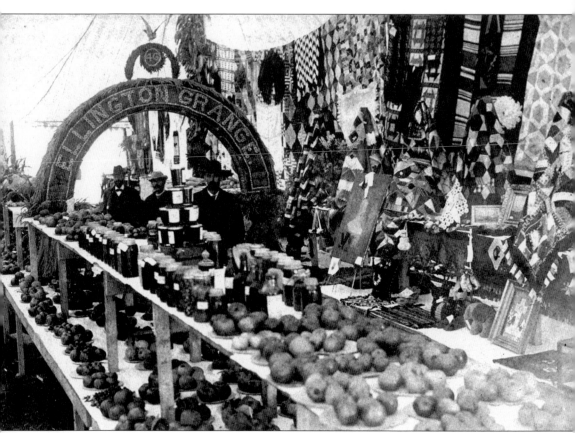

Ellington Grange No. 46 displayed this exhibit of produce, jams, and crafts at the Four Town Fair around 1890. The Grange was organized on May 15, 1886. By the end of the year there were 94 members. One of the benefits of the organization was that goods needed by the farmers could be purchased in bulk and sold to the members. At meetings, held the second and fourth Wednesdays of the month in the town hall, programs were in the form of debates on topics of interest to the Grangers. The 20th anniversary of the Ellington Grange was celebrated on May 9, 1906, by about 125 local members and visitors. Worthy Master John M. Thompson spoke first about the organization's history and its recent purchase of new pianos. This was followed by a piano duet by Mrs. M. A. Pinney and Mrs. F. H. Holton. State master Orson S. Wood, who arranged the program, was a member of the home Grange. The numbers of farmers declined as Ellington became an increasingly suburban community, and the Grange disbanded in 2002. (Courtesy of Connecticut Historical Society, Hartford, Connecticut.)

Frederick G. Klee of Shenipsit Street poses in front of his horse-drawn milk cart in 1923 with his children, from left to right, Pearl, infant William Frederick, and Alice.

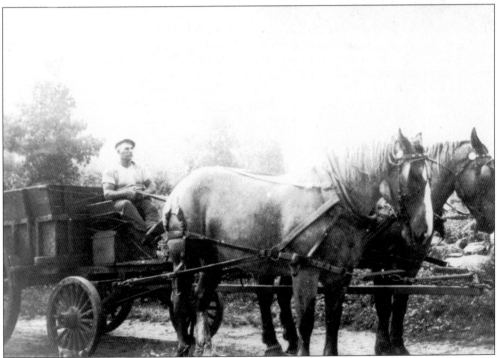

Klee and his team of massive, powerfully built roan Belgian draft horses pull a dump cart on his Shenipsit Street farm in 1935.

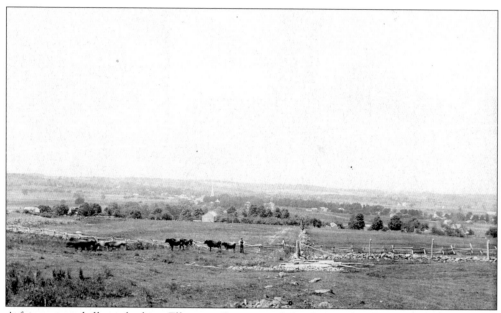

A farmer on a hill overlooking Ellington Center tends his livestock. The stone walls are made from stacked fieldstones, without mortar, and are seldom found outside the Northeast. Between 1750 and 1850, farmers clearing fields created about 240,000 miles of stone walls. Farmers also felled trees to clear the land, and created worm fencing, shown here, because it did not require nails or other fasteners to hold the fence together.

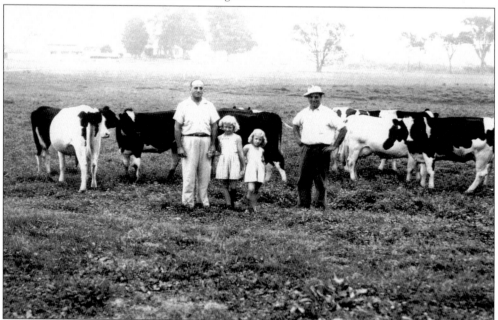

Seen here from left to right, Gottfried, Audrey, Kay, and John Bahler stand in front of their Holstein herd in a misty meadow on Bahler Farms around 1949. Vern, Ron, Dan, and Dave Bahler continue the family dairy business begun by Adolph Bahler, who emigrated from Switzerland in the late 1880s. The family's Oak Ridge farm, on Jobs Hill Road, was awarded Connecticut's Dairy Farm of Distinction award in 2005.

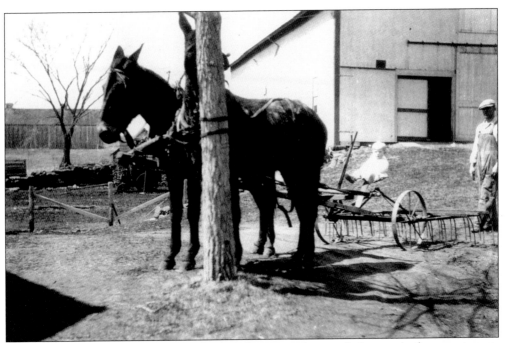

Ken Bahler was truly to the manor born as he received an early lesson on farm equipment behind his father Gottfried's mules on the Bahler Farm while dad looked on, *c.* 1931.

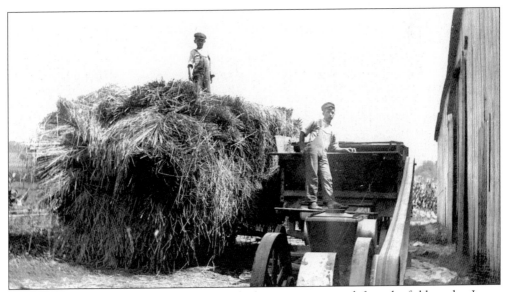

Haying was a big job on a dairy farm. After the hay was cut, it was left in the fields to dry. It was raked, picked up with pitch forks, and tossed onto a hay wagon for the trip back to the barn. It was just part of a day's work for these farm boys.

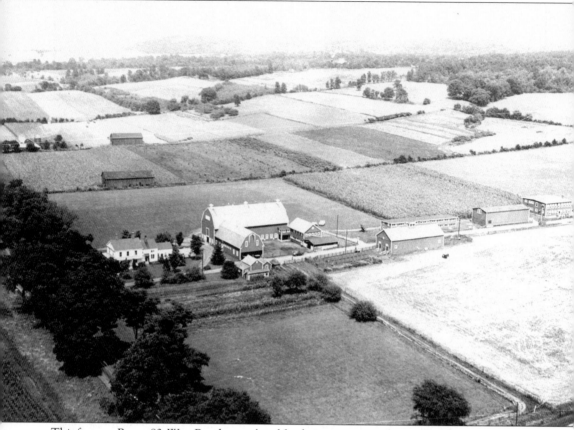

This farm on Route 83, West Road, now slated for destruction to make way for a Big Y Supermarket and single family houses, was for many years a thriving farm engaged in feed research for two large farmers' organizations, the Eastern States Farmers' Exchange and Agway Incorporated. Westbrook Farm was purchased in the late 1930s by Eastern States from George Hughes, a prominent Ellington farmer. The farm grew to 215 acres and 25 buildings, and was engaged in feed research for cattle, horses, turkeys, chickens, swine, rabbits, and dogs. Agway, the merger of Eastern States and GLF farmers' cooperatives, moved its research operations to Fabius, New York, and sold the Ellington farm in 1967 to Edwin Aberle. He sold it to Valley Farms, which, until recently, continued to produce milk.

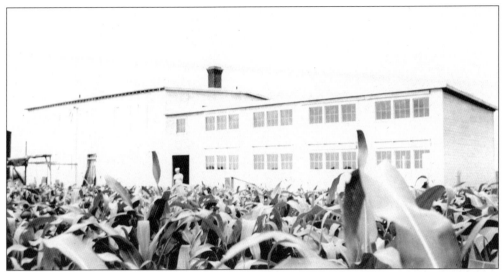

A new laboratory at Westbrook Farm on West Road, built to conduct feed research for two large farmers' organizations, is pictured here on July 15, 1939. It was part of the thriving research farm south of the present location of Meadowview Plaza and Lee's Auto Ranch.

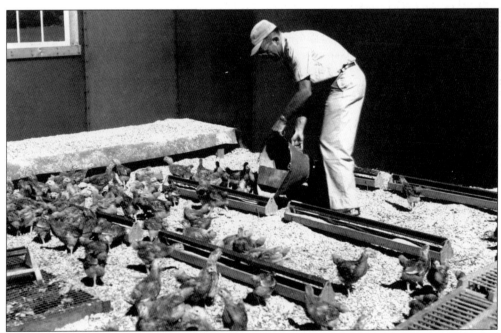

Don Wallace feeds chickens on Westbrook Farm as part of the feed research program. A herd of 125 cows and thousands of chickens, turkeys, and other farm animals produced milk, eggs, and meat products. In addition, seed and fertilizer trials were conducted to make improvements in these products.

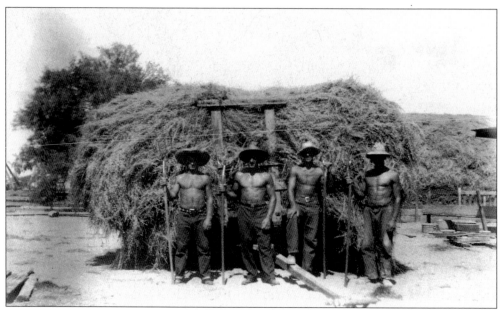

Hany brothers (pictured here from left to right) Walter, Otto, Werner, and Arnold were part of the Swiss immigration to the Ellington area in the late 1800s and early 1900s. Many Swiss immigrants found work in area silk and woolen mills and later bought land and began dairy farming. Others learned trades. From the looks of these men, they got a better workout haying on a dairy farm than at a gym.

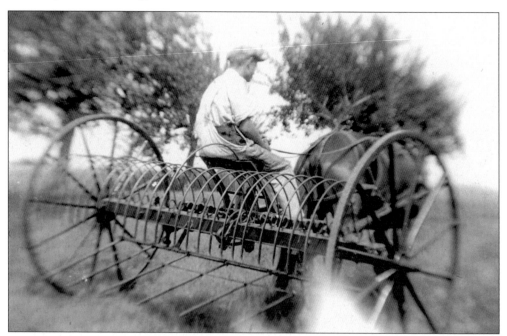

This horse-drawn dump rake gathered hay to feed the dairy cows at the Bahler Farm. The rake tines were lowered and collected hay until there was a full load. The farmer would then engage a cog into the wheel to lift the tines, leaving a windrow. As this operation was repeated, a series of lines of hay were left at right angles to the direction of the travel of the rake.

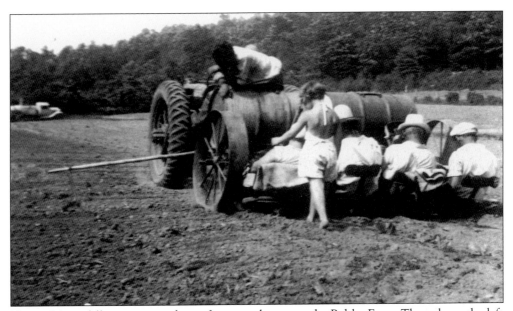

Florine Moser follows a tractor-drawn four-row planter on the Bahler Farm. The pole on the left is a row marker that ensures straight rows.

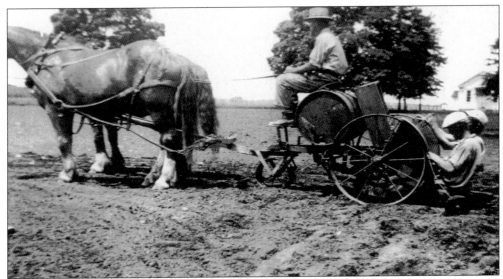

A team of draft horses pulls a 1930s two-row riding planter.

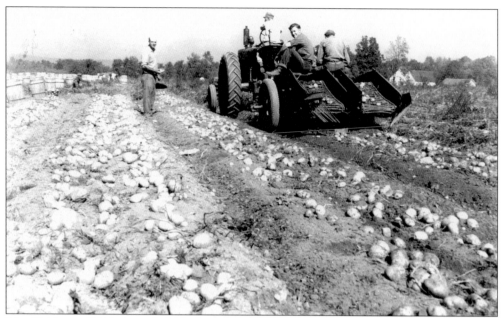

John Bahler and Eddie Luginbuhl look toward the photographer while harvesting potatoes with a tractor-drawn harvester on the Bahler Farm.

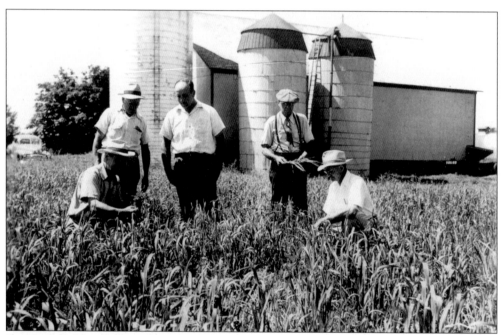

Gottfried Bahler (left) explains his ladino clover pasture irrigation to New England Green Pasture judges and county agent Mr. Elliot (second from left). Two of the others are identified as Benjamin Brown, agronomist at the University of Connecticut, and Richard Foley, chairman of the judging team, dairy department, University of Massachusetts. Bahler Farms was one of the winners in the 1948 Connecticut Green Pastures Contest and placed first in 1949.

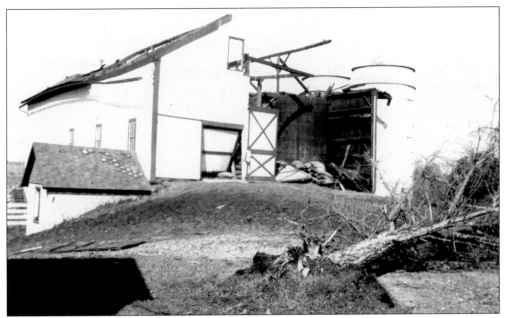

The Hurricane of 1938 on September 21 was one of the most powerful and destructive storms that ever struck southern New England. Rows of trees on Main Street and Maple Street were toppled and changed the look of the town forever. Sustained hurricane-force winds of 91 miles per hour. with gusts to 121 miles per hour caused extensive damage to roofs, trees, and crops, including this barn and tree on the Bahler Farm.

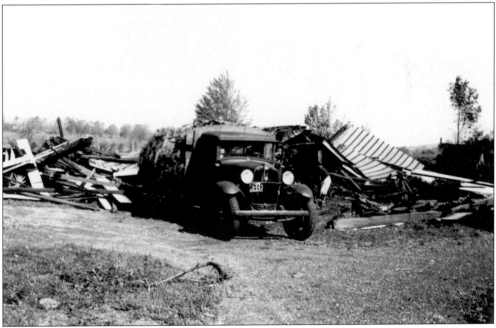

Storm tides of 14 to 18 feet hit most of the Connecticut coast. Ten to 17 inches fell across most of the Connecticut River Valley The hurricane roared through Ellington in just a few hours, but it took almost a month to open Frog Hollow Road to traffic and longer to restore electricity and telephone service. Nearby on the Bahler Farm, this barn was demolished.

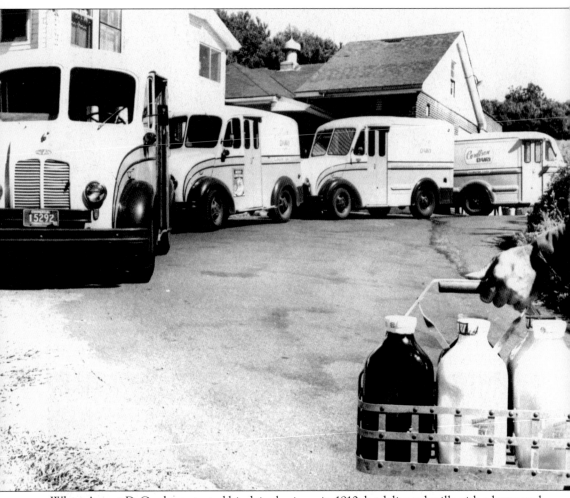

When August D. Cordsten started his dairy business in 1910, he delivered milk with a horse and wagon. Milk was ladled from large metal milk cans into the customer's own container. After August's death in 1921, Clyde Cordsten Sr. and his wife Florence ran the dairy. In 1938, the Cordstens began to pasteurize raw milk. When a coal burner used in the process overheated in June 1941 causing a fire that destroyed the plant, the Cordstens processed and bottled their milk at the Hurlburt farm in Somers until the plant was rebuilt. After gas rationing and tire shortages during World War II, the post-war years brought growth to the business. In 1948, the plant began to process homogenized milk. Cream at the top of non-homogenized milk would freeze and rise out of the bottle when left on the doorstep by the delivery man on cold winter days. Frozen cream was not good for morning coffee, but a treat for the children. Clyde Cordsten Jr. and his wife Lynn ran the home delivery dairy business from 1953 until it closed in 1968.

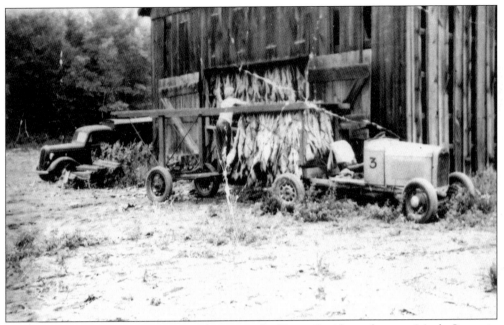

Tobacco hangs in the barn to dry and cure on the Harry O. Aborn farm on Maple Street in 1946. The doodlebug in the foreground was a homemade tractor made from a cut-down, used car. These converted vehicles competed in doodlebug pulls at the Four Town Fair.

Ernie Kupferschmid, pictured here in front of his airplane, won the New England Green Pastures championship in 1953 after having won the Connecticut contest. He received his trophy from Pres. Dwight D. Eisenhower at the Eastern States Exposition on September 21, 1953. The award was for raising the most adequate quantity and best quality green feed for a dairy herd on his farm on West Road.

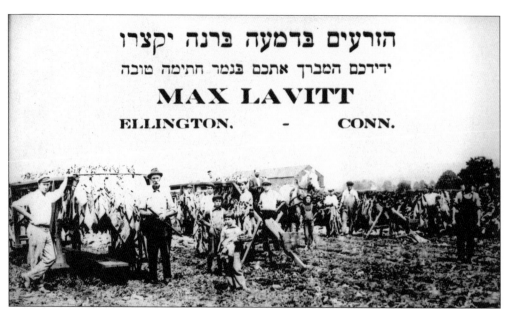

הזורעים בדמעה ברנה יקצרו

ידידכם המברך אתכם בגמר חתימה טובה

**MAX LAVITT**

ELLINGTON, - CONN.

Tobacco was an important crop in the Connecticut River Valley until the 1950s. Shade grown tobacco from the valley made the finest cigar wrappers in the world. Max Lavitt introduced the first shade grown tobacco to be cultivated east of the Connecticut River. Harvesting the 1915 crop at his Maple Street farm, Max is driving the rigging and his sons Samuel, Paul, and Louis are among the group.

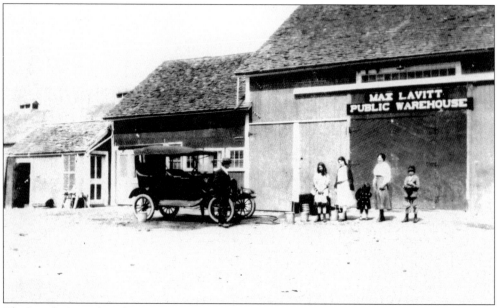

The Jewish Agricultural Society, supported by the Baron de Hirsch Fund, was formed to promote farming among Jews in the United States. The society purchased small farms in Ellington, held the mortgages, and turned them over to Russian immigrants who wanted to become farmers. This barn on the Max Lavitt farm on the north side of Maple Street was converted to a tobacco warehouse in 1916.

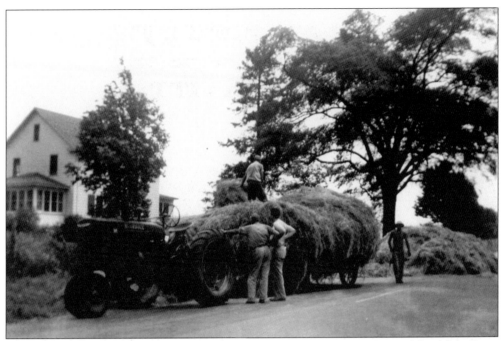

Hay piled too high on the wagon slid off in the center of Route 83 in front of the Albert Lanz dairy farm, *c.* 1950. Shown from left to right in front of the wagon are Ed Sattertwaite and Francis Bird. Don Wallace is on top of the hay. The man at the right is unidentified.

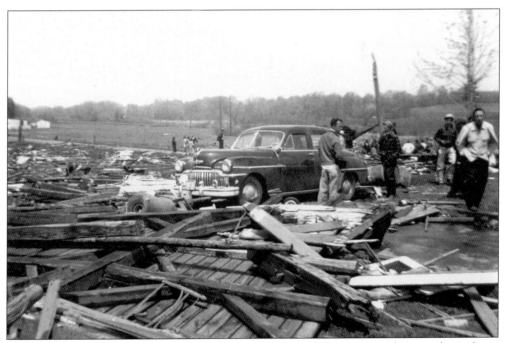

In the 1950s, several tornadoes struck Tolland County. This photograph was taken after a tornado hit Ellington with winds strong enough to push this 1949 DeSoto off the road and flatten nearby buildings.

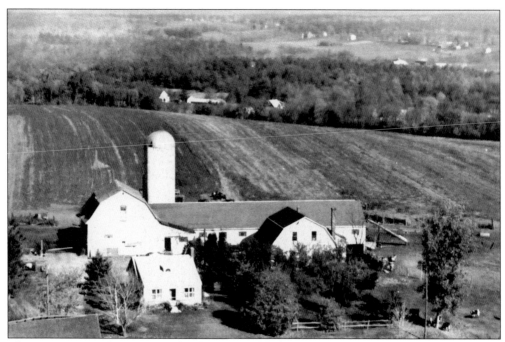

The Lanz Dairy Farm on the north side of Frog Hollow Road is shown in this aerial view looking west toward East Windsor. The silo is the tallest in Ellington and withstood the Hurricane of 1938 although other buildings and the nearby Kelley and Patric farms on Frog Hollow suffered extensive damage.

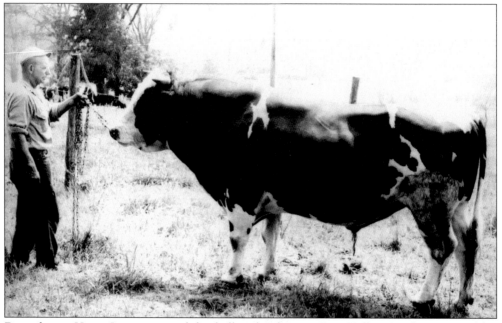

Dairy farmer Henry Lanz poses with his bull on his farm on Frog Hollow Road. Henry and his wife Marie were children of Swiss immigrants who settled in Ellington and became farmers. Small dairy farms were threatened by high costs, the low prices farmers are paid for their milk, and the difficulty of finding farm laborers. The Lanz Dairy Farm ceased dairy farming in 2000.

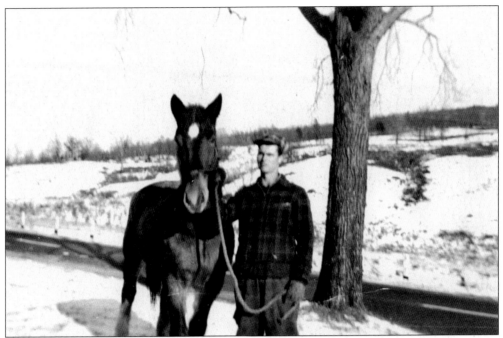

Clinton Charter was a third generation Ellington farmer, who was born on his parents' farm on Somers Road and lived there until his death at age 90 in 2004. He married Mary Wilson in 1938, and together they ran the Charter Dairy. Clinton saw dairy farming change from the horse and plow era to computerized milking. He is pictured here with his work horse on the farm.

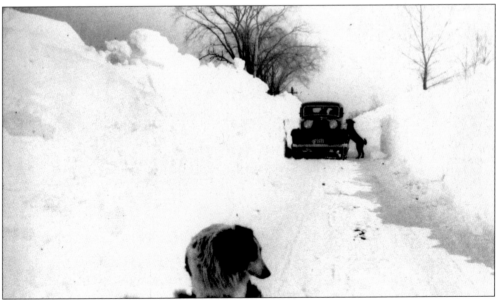

Henry Lanz drives down a narrow path cleared through the snow near his farm on Frog Hollow Road, probably in the 1930s. It is a good thing that traffic was not as heavy then as it is today, since there is no room for another car to pass.

Rob Wallace stands on the running board of Ellington's 1937 Chevrolet fire truck at the 1951 Four Town Fair. The fall fair, first held in 1839, rotated among Somers, Enfield, Ellington, and East Windsor until a permanent location for the fair grounds was purchased in Somers in 1960. This much-anticipated annual four-day event includes livestock and agricultural exhibits, horse shows, exhibits of antique machinery, and a parade.

Growing up on a farm meant taking turns with the milking for David Charter and his three brothers. All went to college with money earned by dairy, tobacco, corn, and vegetable farming on father Clinton's farm. David, pictured here with a Holstein calf in front of the Charter barn, is now a dairy farmer in New York State. His brother Peter and wife, , run the family farm on Somers Road.